ARTS BOARDS

Creating a New Community Equation

Written and Compiled by

Nello McDaniel and George Thorn

Edited by

Barbara Carlisle and Shelley Conger

A Publication of
ARTS Action Issues
New York

TO

Mary Giudici and Nancy Van Rijn,
for your love, patience, understanding,
perspective, humor, and encouragement.
You make it all possible and worthwhile.

Nello McDaniel and George Thorn

CONTENTS

ACKNOWLEDGMENTS

This revised and updated *ARTS BOARDS: Creating a New Community Equation* owes a great deal to the preceding publication *ARTS BOARDS*, issued in 1992, and all those who made that publication possible. We would like to recognize particularly a number of contributing writers to that publication including Barbara Carlisle, Tisa Chang, Robin R. Farquhar, Barbara Hauptman, Ruby Lerner, Patty Lynch, Cathy Mahoney, Keryl McCord, Tim Miller, Becky Russell, and E.G. "Skip" Schreiber. We are very grateful to Barbara Carlisle for editing and to production supervisor Lars Olson.

For making this new publication possible we would like to thank editors, Barbara Carlisle and Shelley Conger, project supervisor, Mary Giudici, and John Boone for design and production.

And as always, our most sincere and profound gratitude to all of the artists, managers, and board leaders who have allowed us to work with them, learn with them, and be a part of their work and lives.

Nello McDaniel and George Thorn

INTRODUCTION

In the introduction to our 1992 publication *ARTS BOARDS/Myths, Perspectives, and New Approaches*, we described our reasons for writing the book in simple terms:

"We want to examine the one aspect of the not-for-profit arts model that is most problematic, most frustrating, and most dysfunctional. No matter where we go, whom we work with, or whatever the nature of the work, the problem highest on everyone's list is 'the board.' Invariably, the arts professionals and board leaders we come in contact with feel a tremendous sense of frustration, failure, and guilt—they are convinced that their board doesn't work because they failed somehow to make it work."

In this regard things haven't changed very much since publishing the original *ARTS BOARDS* in 1992. In the arts field, now also described as dysfunctional, we continue to observe that the arts board is the most dysfunctional aspect of all. It is virtually impossible to work with any not-for-profit arts organization without addressing problems related to the board. It has always been a little mystifying why something that on the surface seems so straightforward, so logical, so necessary, could be so pervasively problematic if not unworkable. We concluded, then and now, that any aspect of an organization's life that is so universally problematic must be therefore more complex than it appears.

Thus, we present this updated *ARTS BOARDS* to reflect our growing understanding, evolving points of view and approaches to meeting the new challenges in the arts field.

Understanding the New Challenges

While certain board challenges haven't changed very much during the last several years others have changed profoundly. In a short period of time, some hard, new realities have brought about new challenges and have reframed many old challenges confronting our arts organizations, our boards, and the place of the arts in society. A number of factors and conditions have conspired to create financial and operating crises unimaginable a decade ago. In addition, a crisis in confidence has grown out of the eroding public and private sector support and has been intensified further by unrelenting, vociferous attacks on the arts by the political and religious right all over the country. We outlined many of these causes and factors in our special report, *The Quiet Crisis in the Arts*, in 1991.

As we expressed in *The Quiet Crisis*, these new realities have added both greater threats and opportunities to the complex equation of arts boards and the arts' relationship to its many communities. When *ARTS BOARDS* was issued in 1992, the deficiencies of boards from both the arts professionals' and board members' points of view were basically benign. Problems revolved around board functions that were not working well or overall board deficiencies. Conflicts between staff and board and within boards were primarily internal or personal concerns. Today, there is nothing benign about these conflicts.

For example, while debt is not a new phenomenon in the not-for-profit or profit worlds, few community leaders serving on arts boards in recent years ever imagined the kind of financial challenges they would face. Few if any had been prepared experientially, financially, or emotionally to deal with the scale and impact of debt and organizational breakdown. Most board members had no idea that

they might be placed in the position of making life or death decisions about their institutions.

For many, the thankless work of board service has become a punishing obligation, and in extreme cases, a real threat to certain board members' personal resources and livelihood. What may start out as someone's simple, good-hearted intention to help an organization and the community can easily turn into a nightmare of enormous complexity and implication.

In addition to the intimidating financial and organizational issues, there is a whole new set of challenges posed by the growing force of the religious right across America. For many years, convincing an indifferent community of the role and value of the arts was sufficiently challenging for most arts organizations and boards. Arts leaders had learned to live with the unenthusiastic yet consistent lip-service support that most communities offered.

But the maturing of an organized and activist religious right has brought the alarming specter of censorship and blatant, angry opposition to the arts in a growing number of communities. If board members had difficulty dealing with indifference, they now are overwhelmed with defending not only their organizations, but also the arts in general against the distortions and combative actions of the political and religious right.

The religious right has targeted the arts along with a number of other groups and movements such as Planned Parenthood, gay and lesbian rights groups, and public libraries as the evils of secular society. Consequently, arts organizations and their board members must not only fight for their organizations but also the various communities and movements targeted by the religious right. For potential arts board members, it is no longer a simple choice of liking the work of an organization enough to promote it. Increasingly, joining an arts board means joining a larger and more complicated entity. Invariably, a community under siege.

The activism of the religious right has also skewed and

confused many relationships which were taken-for-granted only a short time ago. Around the country, the religious right has made its strongest gains by getting its candidates elected to local county, city, and town councils and to various school boards. Its success in this area has been due to the "stealth strategy." That is, the religious right grooms "stealth" candidates who, according to Christian Coalition Director Ralph Reed, "fly beneath the radar to put themselves into [elected] positions where they can apply their values to public policy." The Christian Coalition in particular is actively training and grooming stealth candidates all across the country. According to The New York Times article of April 25, 1993:

> The Christian Coalition is expanding rapidly across the country, with plans to run two-day seminars, or Leadership Schools, in 33 states this year. Under the motto "Think like Jesus ... Fight like David ... Lead like Moses ... Run like Lincoln ..." each seminar is designed to teach people how to run campaigns, put together grass-roots organizations and influence local policy making.

More recently, certain elements of the religious right have begun to apply the stealth candidate strategy to not-for-profit organizations. Arts professionals are now dealing with "stealth board members;" that is seemingly innocent, innocuous volunteers who express an intense interest in the arts organization, seek board membership, and quickly achieve board leadership roles. Then, having achieved these positions, they assert their own values and agendas.

Board recruiting has never been a process to take lightly. But the stakes have changed dramatically. In the past, poor recruiting may have meant nothing more than adding to the board's "dead wood pile." Today, enlisting a new board member who does not have a proven track record of commitment to the organization's work could be a blunder of enormous and dangerous proportions.

For better or worse, our arts organizations are inextricably linked to the swirl and contingency of all human and world events. Writing and compiling this book has been an important step for us by taking our questions, concerns, and doubts about arts boards public. By posing the right questions, we get better answers and a better understanding of contemporary challenges. By taking a truthful look at what doesn't work and why, we can begin to understand what can work.

Developing New Responses

During the last several years, all of our work in addition to our views of arts boards, has changed dramatically. The greatest influence has stemmed from our growing understanding, exploration, and application of the creative process as the principal tool for reframing, refocusing, and even reconceptualizing all aspects of arts organizations.

That is, we now understand that the creative process—the process of making art—is the single most effective planning, problem solving, and decision making process available. We believe that the values, roles, relationships, and decision making involved in the creative process should serve as the framework for all functions and relationships within an arts organization.

Ultimately an organization is successful because of the artistic work and programs it produces, presents, or exhibits. Each group of artists has its own distinct process for creating work, and this process should be used as the operating paradigm for everything in the organization.

The creative process requires ethics, discipline, structure, intuition, trust, risk, flexibility, and collaboration. Every day, artists use the creative process to solve complex problems in their work. The production of a play is an apt example. A diverse group of people (playwright, director, designers) agrees on a common vision. A period of research and exploration follows as the group refines the conceptual

approach and metaphors for the production. However well-researched and well-planned the play, it is not until the playwright, director, performers, and technicians are in rehearsal that they begin to work through the play's text and intent.

These rehearsals are a process of peeling away layers to get to the truths of a piece. During this process, artists encounter obstacles they had not anticipated. Overcoming these obstacles requires leaps into the unknown. The process cannot stop; it has to go forward. It doesn't matter who has an answer; finding an answer is what is important because the curtain will go up at 8:00 p.m. on opening night.

We have come to realize that no other process matches the rigor of the artistic process for on-time delivery, use of resources, "customer" (audience) relations, trust, ethics, collaboration, discipline, intuition, risk, and commitment to quality. The processes used in the political, manufacturing, banking, ecclesiastical, and educational arenas cannot meet the standards set by the artistic process.

Arts professionals are often accused of not running their operations "like a business," of not understanding the "bottom line." In fact, the artistic process is an endless series of unforgiving bottom lines. An 8:00 p.m. curtain is an unmistakable bottom line. The production budget, the production schedule, the number of rehearsal weeks—all are bottom lines. Presenting art to an audience and critics is a particularly unforgiving bottom line. Arts professionals understand and adhere to the demands of the bottom line as much or more than professionals in any other sector of society.

Unfortunately, our society undervalues and underutilizes artists and the creative process. Artists and their processes have been isolated in rehearsal studios because the artistic process has been considered inapplicable to the "real world." Bringing the artistic process into the center of the organization—as the primary decision making, planning, and problem solving process—can solve or better address the issues that plague most arts organizations. Although an arts

organization must rely on sound financial principles, it is not like running any other business.

In order to bring the creative process to the center, arts leaders must understand the need, value, and role of the process outside of the rehearsal studio. The artists and the creative process are our most valuable assets. The challenge then is how to understand and apply these important assets to the entire life and function of our organizations.

This updated edition of **ARTS BOARDS** is both a reflection of how our views, understanding, and approaches have changed and a foundation for how they will continue to change in the future.

THE ARTS EXPERIMENT

During the relatively short life span of the not-for-profit arts, no aspect has been more discussed, scrutinized, or debated than the board of directors. Or is it the board of trustees? That's part of the problem—we still don't really know how to talk about boards. But we talk of little else. Boards are at once the problem and the solution—any arts professional knows what a successful board looks like, but few if any have ever really seen one. We know how a successful board member performs, but the good ones we know tend to be the exceptions and not the rule.

Few things about the not-for-profit arts model are simpler or more straightforward than boards. Virtually any staff member of an arts council can describe the size, shape, and function of a good board. Consultants who have never even run an arts organization make money talking about boards. Articles and books are full of board wisdom. Everybody understands about getting "heavy hitters" on the board and putting committee structures into place and bringing good solid business sense and accountability to the organization—but over the years the performance of "the board" has fallen far below the promise. And if we aren't blaming the boards themselves, we're blaming the arts professionals.

It should seem obvious that anything as simple as the not-for-profit board must, in fact, be very complex. And maybe all the good people who give of themselves and work so hard as board members and arts professionals aren't villains. Perhaps there is more to the

matter of boards in the performing arts, to how we inherited the concept and have attempted to put it into practice to satisfy so many needs of our artists, organizations, and communities.

After 20 to 25 years, the not-for-profit arts experiment should be enjoying the fruits of the experiment. Unfortunately, the beginning of the not-for-profit arts experiment happened to coincide with other, more profound changes in our country and the world. That is, what should have been the end of the beginning of the arts experiment coincided with the beginning of the end of the industrial era in the U.S. and the world. And with this profound change a lot of behavior and a lot of assumptions need to be reevaluated and changed. But to do this we need to take a look at some aspects of the larger context. Even something as simple as the not-for-profit arts board has historic and ideological roots that may help illuminate not only the performance problems of boards but the very basis of the concept and its future.

Before looking at some of the questions and contradictions of today's boards, we need to examine some of the historic and ideologic context.

Americans of all ages, all conditions and all dispositions, constantly form associations. They have not only commercial and manufacturing companies, which all take part, but associations of a thousand other kinds—religious, moral, serious, futile, general or restricted, enormous or diminutive. The Americans make associations to give entertainments, found seminaries, build inns, to construct churches, to diffuse books, to send missionaries to the antipodes; they found in this manner hospitals, prisons and schools. If it be proposed to inculcate some truth, or to foster some feeling by the encouragement of a great example, they form a society ... The English often perform great things singly, whereas the Americans form associations for the smallest undertakings. It is evident that the former people consider association as a

powerful means of action, but the latter seem to regard it as the only means they have of acting.

Alexis de Tocqueville
Democracy in America

De Tocqueville's insights into the American civil and social character can be very helpful as we consider the birth, growth, and current condition of the board of trustees in the arts in America. While it's important to understand the legal genesis of the not-for-profit entity and the underlying governing principles, we can't separate the human, communal, and ideological impulses from our examination of the board and the not-for-profit arts framework.

As de Tocqueville observed, there is something very basic in Americans' need to come together to bring about positive change for the common good, behavior in stark contrast to the image of America as the land of the rugged individualist. We might glean from this, then, that somehow, in the genetic blueprint of each not-for-profit arts organization, there is that fundamental human and social impulse present that was simply made formal by legal process—law imitates life, as it were.

While an interesting notion, we need to examine the performance of this legal entity that American life and law hath wrought on and for the arts and the greater common good. Today, most arts professionals and board members of not-for-profit arts organizations agree that there is quite a gulf between the theory and good intentions and the level of performance of the not-for-profit arts board. We must pose the questions, why the gulf and why the contradictions between intention and performance?

It's helpful to remember that one of the driving impulses behind de Tocqueville's research and writing about America in the 1830s was to understand better the differences between Americans and democracy. To many, in the 19th Century and today, democracy and America are synonymous. While giving America its due, de

Tocqueville obviously drew major distinctions between the two and did more than anyone to help us understand the contradictions between our ideology and our realities—even as we struggle to better understand these distinctions today.

A curious, nearly invisible outgrowth of this country's unique history, which we Americans tend to take for granted, is our openness to social experimentation. Those Europeans who undertook the long and dangerous voyage to the New World were often disenchanted with the social systems in which they had lived. They were determined to make a better life for themselves and their heirs. Pennsylvania and Rhode Island were founded as experiments in religious tolerance. The Massachusetts Bay Colony was an experiment in Protestant theocracy. The willingness to experiment is occasionally seen even in modern days, as evidenced by the social unrest of the 1960s and early 1970s.

Another astute observer of the American odyssey, Arthur Schlesinger, Jr. states, in his book *The Cycles of American History*, "The American character is filled with contradiction and paradox... at the same time Americans live by experiment they also show a recurrent vulnerability to cosmic generalities." Schlesinger sees this contradiction in the American character deriving from two sources. First is the commitment to experimentation, which is the pragmatic reality of the American system. Second is a sense of destiny derived from theology and secularization of theology, which is ideology. According to Schlesinger, "The conflict between the two approaches expresses the schism in the American soul between a commitment to experiment and a susceptibility to dogma." We observe this contradiction in our foreign policy, which in effect states that while we have a profound belief in our own experimentation, we have no belief or confidence in the experiments of Vietnam or Nicaragua. In our domestic policy, we have a profound belief in individual rights and freedom; yet, one of the most intense debates in the country today is whether women deserve the individual right to choose abortion.

THE AMERICAN EXPERIMENT

It is helpful to keep in mind, as de Tocqueville pointed out in the 1830s, that "the Americans are a very old and a very enlightened people who have fallen upon a new and unbounded country, where they may extend themselves ... and fertilize without difficulty." Unlike all other nations of the world at that time and this time, America and most of its political and social institutions were born fairly full-grown. The American Revolution was a democratic "big bang" as well as a conflict between countries and people. Thus, the American experiment began drawing upon existing and available experience and knowledge which was, of course, European. It's not to say that this was a bad body of information and experience to draw upon, but it was culturally specific to Europe and based upon a very different ideology from that developing in America.

Reconciling these contradictory elements of experimentation and ideology in our domestic and foreign behavior, in our political, social, economic, and ultimately our cultural institutions has been and continues to be a challenge to Americans. For example, with regard to Americans' attitude toward and about supporting the arts, de Tocqueville wrote, "[Americans] cultivate the arts which tend to render life easy, in preference to those whose object is to adorn it. They will habitually prefer the useful to the beautiful, and they will require that the beautiful should be useful." When it comes to utility rather than adornment, or challenging ideas and values rather than simply mimicking or supporting established ones, contemporary America has much in common with the America of de Tocqueville's time, evidenced in part by the furor over the work of Mapplethorpe and Serrano.

THE NOT-FOR-PROFIT ARTS EXPERIMENT

An interesting parallel to the way this country's great experiment was put in motion was the advent of the not-for-profit arts field in the mid-1960s. When it was determined "that the encouragement

and support of national progress and scholarship in the humanities and the arts ... is an appropriate matter of concern to the Federal Government" the National Endowment for the Arts was created. For both pragmatic and ideological reasons, in order to serve the public good, it was a fundamental aspect of the enabling legislation of the NEA that legal organizations, incorporated under 50l(c)(3), not-for-profit tax-exempt status could receive funding support. So in very short order, the not-for-profit arts industry as we know it today was born fairly full-grown.

Prior to this, of course, there were a few arts organizations incorporated as not-for-profit, tax-exempt entities, most notably museums and symphony orchestras. But theater existed largely as a commercial entity centered in the Broadway district of New York. And dance was defined largely by relationships as dancers gathered around a particular choreographer who created the work and had the dancers perform the work in New York and on tour for whatever income could be generated. The only artists acknowledged to be independent were visual artists. Virtually all non-white, non-Eurocentered art forms were considered folk, ethnic, or craft expressions. These forms were later acknowledged through the establishment of the Expansion Arts Program at the NEA.

The birth of the NEA signaled a kind of cultural "big bang" in America. The arts were legitimate, money was available, and a new order of business was virtually legislated into being. But like America itself, this was an experiment that involved enlightened people who would give rise to a new order of institutions based upon empirical knowledge and driven by the energy and fervor of destiny characteristic of many government programs born of the "Great Society." The empirical knowledge in this case was drawn from a rather broad body of information regarding the life and operation of other not-for-profit endeavors in America such as hospitals, zoos, and charities. It was not a bad body of information, but like the early evolution of the country itself, it was culturally specific, lacking in diversity, Eurocentric in

nature, and drawn from very different ideologies than the arts.

Clearly, the newest and most vague aspect of the not-for-profit arts experiment was the legal corpus, or the board. The not-for-profit legal requirements were specific regarding the number of board members necessary to constitute a legal corpus (three in most states) and regarding fiduciary responsibilities (i.e., the organization spends the money the way the board agrees it will be spent, and board members shall receive no remuneration for participation as the board), but little or nothing else was specified with regard to function or role of the board.

To the not-for-profit arts experiment, the board concept, as new and ill-defined as it was, felt pretty good and seemed to make sense. As de Tocqueville observed, it satisfied the American need to get together in an association to make something good and important happen. It also satisfied the ideological requirements by serving the public interest and good through de facto involvement as the board. In this way it was a perfect outlet for what Daniel Yankelovich refers to in his book *New Rules* as the Giving/Getting compact. The Giving/Getting compact aligns private or personal goals with public ones and not only eliminates guilt associated with personal gain and ambition but makes unlimited gain virtuous if appropriately connected to public or community service. According to Yankelovich, "a growing America gave people something to work for: a conviction that a way of life built around growth paid off for the individual and for the [community and] country." Therefore, you can be as greedy as you like as long as you put something back into the community.

Less acknowledged but clearly implied in the concept and structure of the not-for-profit board is that it would assure accountability of the artist and art not only so that "the beautiful would be useful" but the artist and art would add to community and culture at large rather than advertently or inadvertently challenging or altering values and beliefs. The board concept was especially helpful in resolving yet another contradiction in the American psyche, that public

support of individuals and projects that improve and enhance the quality of life is good, but no individual is trustworthy enough to separate personal ambition and economic motive (greed) sufficiently to be worthy of that support.

The not-for-profit arts experiment pulled together so much of what was known and satisfied so many ideological needs that it always seemed that just a matter of time and correct players stood between any given arts organization and a good, effective, policy-setting, fund raising, and accountable board of directors.

For a number of years the human and financial resources available to the new and developing arts organizations were sufficient to obscure the fact that the board theory wasn't working as expected or needed. Indeed for the first decade following the creation of the NEA, the funding climate was so positive and the lack of competition for the contributed income dollar was such that the most inactive or inept board could succeed. At the same time, as financial resources were positive, human resources were likewise very positive. The not-for-profit arts experiment had the initial good fortune of getting underway precisely as the "baby boom" generation started to enter the American work force. This largest, best educated and most idealistic of generations in the life of America were eager and willing to take low-paying, learn-as-you-go jobs with young, developing arts organizations. If a working board didn't work, more often than not it didn't matter because smart, young, energetic staff stepped in to make the difference.

Something else quite subtle but profound took place during this initial decade which might be described as the institutionalization of the ideology. That is, the not-for-profit arts experiment, even as it was evolving, became the standard and expected behavior for all arts organizations.

To receive funding, an arts organization had to achieve a look and level of both artistic and organizational behavior—or at least the appearance of the expected behavior. This is an important point.

During the most positive years of funding and growth in the arts arena, many artists of color, of non-European cultures, or highly experimental in nature simply could not measure up to the organizational behavior expected. And that standard was used to withhold funding and endorsement or deny funding altogether. Of course, some African-American, Latino, Asian, and experimental artists put together the "right" kind of board and staff and succeeded in the funding arena. But most did not. The standard became so defined ideologically that it was usually easier to understand who didn't qualify for funding and why, than who did. It is perhaps appropriately ironic that many of the arts organizations that participated in the early not-for-profit arts experiment and helped establish the standard are now experiencing the retaliation of not being able to measure up when the structure and theory fail to work and debts begin to mount.

THE SIGNS AND SYMBOLS OF STRESS

In the late 70s and early 80s there was a confluence of factors that started to have a major impact on the not-for-profit arts experiment. Funding, both public and private, slowed and in some cases was cut. Funding for all not-for-profit activity in America leveled or was reduced, placing greater demand on available dollars to all. The proliferation of arts organizations accelerated, creating even greater competition for earned and contributed income. The baby boomers got older, moved on to other interests or were absorbed into the expanded arts landscape. And the boomers weren't replaced by a similar sized pool of human resources—thus the era of the "baby bust." As a result of these and other factors, the not-for-profit arts experiment started showing the stress and weight of the times.

Perhaps nowhere did the stress show more than in the board and the relationship of the arts professionals to the board. The relationship between artists and board has always been a little uneasy and ambiguous. But differences and ambiguity were easy to overlook in exchange for grants and as long as the budget balanced.

THE GIVING/GETTING COMPACT RECONSIDERED

As referred to earlier, the American propensity for getting together in associations to make things happen was strengthened in the post-World War II era by what Daniel Yankelovich refers to as the Giving/Getting compact. The Giving/Getting compact is an important modern industrial value, which prevents an impersonal industrial society from fatally weakening the bonds of community. To be socialized is to want what society wants you to want; and by giving to the society what it needs to thrive you get what you need. The more you give the more you get; and conversely, the more you get, the more you are expected to give.

The Giving/Getting compact actually functions very simply in most aspects of life. A person might hate her/his job, but demonstrating commitment and devotion to that job in spite of it all would result in important rewards from the job—salary, promotions, security, and status. One might be unhappy with a marriage, but commitment and devotion brought rewards in the form of family.

This is really not as cynical as it may sound. The Giving/Getting compact is the glue by which many otherwise incompatible marriages held families together, an important reason why America became such a strong economic power, and how most not-for-profit and charitable activities held together and functioned within a given community. And for a lot of years the important factor about the Giving/Getting compact was that it worked very well and very honestly. Much was demanded but much was given.

One of the great appealing things about serving on a board of trustees of a performing arts organization in the late 60s or 70s was that it qualified under basic terms of the Giving/Getting compact. Board service was roughly equal to community service. And the first generation of arts professionals was highly successful in aligning their institutions and private goals to the larger goals of the community. It quickly came to be accepted that a healthy, progressive, economically

and culturally strong community would be known by the institutions it kept—a university, a research hospital, a zoo, a symphony, a theater and so forth.

But according to Yankelovich, a lot of Americans have been rethinking and rewriting the Giving/Getting compact in all aspects of their lives in recent years. Many Americans now believe the old compact may demand too much and give too little in return as they consider their own hectic and demanding lives. And as tens of millions are rethinking and rewriting the Giving/Getting compacts in their personal lives, the effects are obviously beginning to show in the public arena.

Unfortunately, the Giving/Getting compact doesn't address what happens when the jobs and behavior required begin to function outside the understood terms. That is, when the money that needs to be raised exceeds what appears to be available; when choices have to be made between one worthy cause and many other worthy causes; when one's personal and professional life become more complex and quality-deficient than can realistically be improved or offset by participating as a board member. For a lot of reasons the not-for-profit arts are failing to attract and maintain the time, care, and attention of community volunteers through the terms of the old Giving/Getting compact.

The Giving/Getting compact has also broken down for the arts professional. As noted earlier, arts professionals gladly, almost gratefully, gave the authority and control of their organizations over to community volunteers in order to get the financial and human resources necessary to do their work. And in spite of some uneasiness about the arrangement and ambiguity regarding the roles and relationships to these governing volunteers, a lot could be overlooked as long as the resources were forthcoming.

But when the funding got tight and competition for contributed income increased, and deficits became part of the operating reality, things changed. The terms of the relationship and partnership

changed and the results ranged from bad to worse. In the worst case, the arts professional found the board assuming more and more control as it attempted to realign the arts organization with the community Giving/Getting compact. While there may be many and complex reasons for the stress, board instinct is to reduce or eliminate the real or perceived alienation from the community. In extreme cases, this may mean firing the artist or manager, or both. Almost always it means repositioning the arts organization to serve the community in simple, straightforward, back-to-basics terms. When this occurs, many arts organizations cease being community organizations with artistic missions and become arts institutions with community missions. Sadly, but from the point of view of some board members, private and public goals realign, the organization becomes useful (not just an adornment), and any aspect of the organization that may be advertently or inadvertently objectionable is corrected.

In the good times the hot issue between arts professional and board was whether it was actually a board of "directors" or "trustees." Arts professionals maintained that "directors" was a corporate or "for-profit" term, inappropriate to the not-for-profit arts experiment. Additionally, "directors" was a bad term as it implied some involvement in artistic direction, which was clearly not the case in any self-respecting, ideologically sound not-for-profit arts organization. In fact, however, most boards exerted greatest involvement in matters of budget, which had everything to do with what the artistic director could or could not do. "Trustees" was correct because the corporation was being held in trust for the greater common good.

In most cases the boards of arts organizations quickly and eagerly conceded this debate to the arts professionals. Some board members conceded because they truly believed and agreed with the artists' contention; most conceded because they knew that as the board they legally held ultimate authority whether they were called board of directors, board of trustees, or board of toads.

This "director/trustee" debate is one of a number of the great

mind-numbing non-issues that many arts professionals and consultants engaged in during the 70s and early 80s because that was easier and less risky to deal with than the real issues.

But in recent years the real issue has begun to surface. More and more in both developing and existing arts organizations and in funding circles, the questions have to do with control or "governance" of arts organizations. The word governance is certainly less ambiguous and open to interpretation than other words in question. The dictionary tells us that governance or to govern means: 1) to control; guide; direct; 2) to rule by exercise of sovereign authority; 3) to regulate or determine; 4) to restrain. So the question of governance is simple and straightforward: WHO controls, guides, directs, WHO rules, WHO regulates, WHO restrains? While it's good to have the real issue on the table, the disturbing and alarming fact is there are no satisfactory answers to these questions. And chances are pretty good that if the questions of governance are being asked, then objective answers aren't really being sought. And some truly provocative and productive questions aren't being asked:

• Is there a place for the not-for-profit arts experiment in post-industrial America?

• Is there a role for non artists and non arts professionals from the community (however community is defined) in the arts experiment?

• Is there a way to satisfy the society's need for artists and the artists' needs for creative expression without threatening basic values, beliefs, and societal stability?

• How can a true partnership of artists, audience, and community be forged?

THE CHALLENGE OF BOARDS TODAY

The need for leadership and fund raising in the not-for-profit sector borders on desperation. If one could poll all not-for-profit arts organizations, the number one priority of the great majority would be board development. In an initial round of individual meetings that ARTS Action Research conducted with a consortium of Atlanta Theatres a couple years ago, 14 of 15 groups named board development and expansion as their number one need, their number one solution to problems, and, consequently, their highest goal. Funding sources and community leadership continue to believe that board development is the solution to whatever ails an organization. Board development remains the "solution du jour" preferred over the other quick fixes of long-range planning, market research, and audience development.

THE MYTH OF THE "MODEL"

There has been and continues to be an imagined model of the "real" board we should all aspire to realize. If we could just get it right we would solve all of our problems and have all of the resources we need. The fact that we have problems or do not have the resources we need is because we do not have it right—yet. Getting it "right" has meant disregarding our natural constituency, and identifying some "big-guns, heavy-hitters, and corporate CEO's." Then we somehow trick them into joining our board and hope they will somehow miraculously come to love the work and will understand all the organization's needs. They will then transform themselves into passionate believers and proceed to raise money from each other and give it to us.

Our experience at Arts Action Research leads us to believe this ideal is not achievable today. Perhaps it has never been. In the '70s and early '80s there was enough money around so it did not matter if the board did not function the way it was supposed to. Now, with organizations under stress and in crisis it has been revealed as unworkable and dysfunctional.

A quintessential example of the pressures for contributed income, and the consequent trade-offs not-for-profit organizations are experiencing, is the Lee Atwater incident at Howard University in March 1989. Howard is a predominantly African-American university whose mission is education and the enhancement of the African-American experience. That March, Howard University students took over the administration building to protest, among other issues, the appointment of Lee Atwater to the Howard Board of Trustees. Atwater had directed the Bush presidential campaign and had just been elected chair of the Republican National Committee. Because of his approach to the Bush campaign, with its famous "Willy Horton" scare tactic, and his statements, among others, about South Africa, the students believed Atwater, at best, was perceived to be a racist and, at worst, was a racist. The students saw his appointment to the board as contrary to the mission of the university.

One wonders about Atwater's motives in joining the board. Was it a way for him to try to change his image? A way to demonstrate that the Republican Party was sensitive to minority concerns? It is less mysterious to determine why Howard wanted him. The president of the university, James E. Cheek, stated that Atwater was appointed to the board with the hope that he would lead the university to rich Republicans. President Cheek, who said in an interview a few hours after the protest ended that most of the student's demands were "well merited," still did not think the Atwater appointment was a mistake. "Howard will find it harder to raise money without Lee," he said. "It's a shame."

The role, responsibilities, expectations, duties, recruiting, structure, decision making, and relationship to the art and the staff of a board of trustees have always been difficult and complex. Choreographing dances, mounting exhibits, making music, providing services to arts groups, and putting on plays are a piece of cake compared to developing a leadership and fund raising board.

In a world of dysfunction, we believe that the board is the most dysfunctional aspect of most arts organizations. Board operation and development is the common cold of the arts. Everyone has one and everyone is looking for a cure. Like the cold, there are a lot of remedies but no cure. The amount of staff, board, and consultant energy that has gone into boards is extraordinary. Why this dysfunction? We have great respect, admiration, and affection for people who share their time and talents with arts organizations. With so many good intentions, why does it not work? If Winston Churchill were alive and working with not-for-profit arts organizations, he might say, "Never have so many people been so dedicated, given so much, worked so hard and given so much of their time for so little success and reward."

A Confluence of New Community Realities

Several factors in recent years have had a major impact on the terms, conditions, expectations, and needs of community participants in relation to their involvement in not-for-profit arts organizations. For example, there are new realities for the people we look to as board members and volunteers. Since the mid-eighties their lives have become more and more complex.

Most working professionals—banking, law, accounting, corporate—are now working 60 to 80 hour weeks. Arts professionals thought they were the only people who worked 60 to 80 hour weeks. Now almost everyone is doing so. As a nation we are placing increasing professional expectations on ourselves. According to one Census Bureau survey, American leisure time declined by 37% between 1973

and 1987—from 26.2 hours per week to 16.6 hours. For example, new lawyers in Philadelphia firms are expected to bill 250 more hours a year than 6 years ago. In the past, most firms gave "release" time for community service. Today firms have eliminated release time but still expect community service after 60-80 hours of professional obligations.

A woman working for a financial services firm found herself working 80 to 90 hours a week and traveling a great deal. She asked her firm if she could work half-time. The firm was pleased because they did not want to lose a valuable employee. She had to quit anyway; the half time expectation of the firm is 40 hours a week.

Because of downsizing, takeovers, mergers, and forced early retirements, there is a great deal of insecurity in the professions of banking, law, accounting, and corporations. We have gone from the big 7 accounting firms to the big 4. According to The New York Times, 48% of law firms are laying off attorneys. This insecurity is causing the world we generally look to for board members to invest even more in their work, making people seriously rethink their availability and commitment to community services.

A theatre we worked with had as its board chair the president of the dominant bank in the community. What better profile for the board chair of an arts organization? However, the board chair's bank was taken over, and he was suddenly out of a job. No book on boards would recommend that the board chair be unemployed. In another organization, the board president was head of marketing for a local corporation. Because of downsizing, he had to take early retirement. This individual, in his early fifties, must now find a new job or career.

We hear and read a great deal about burn-out and stress management. Dr. Bruce A. Baldwin, a psychologist, gives this suggestion for reducing stress in his new book, *It's All in Your Head: Lifestyle Management Strategies for Busy People!*, "At this point in your life, you most likely have picked up a number of obligations outside of your home life or profession. These may involve committee work of

various types, an officer in a civic organization, or volunteer activities. Examine these time-consuming extras carefully. If any of them is no longer fun or fulfilling, phase it out." The consequences for board jobs that are not fun or fulfilling should be quite obvious.

Another change in the environment is the transition to the two-working-persons and single-parent households that has taken place over the past 8 to 10 years. While we have not begun to understand the sociological implications of this shift, the effect it is having on arts organizations' boards, volunteers, and audiences is enormous.

An important resource to all working in the not-for-profit arts field regarding the changes in work and lifestyle is Juliet Schor's book, *The Overworked American: The Unexpected Decline of Leisure*. Schor dramatically articulates and documents the extraordinary degree in which most American's leisure time has given way to increased work and family responsibilities, especially since the late 1970's.

As the financial resources of a community are stretched further and further and the needs continue to expand, the pool of human resources diminishes. Every non-profit is desperate for volunteers, board members, and funding. Everyone from the community who is interested in serving is besieged with requests for leadership, time, and money.

One of the reasons for board dysfunction is directly related to the expansion of the community's needs. Board members are confronted by homelessness, begging, and the breakdown of infrastructures. Not surprisingly, they feel beleaguered as they begin to undertake the work of their organizations. The needs of the community have become overwhelming, and the needs of each arts organization appear to be overwhelming.

Consequences of the Community Stress Factors

Because of the combined effect of these new realities, community leadership is becoming more task-and project-oriented and less interested in the ongoing responsibility for the life of an organization.

If people agree to perform a task, they know they can get in, get out, know how to do the job, how long it will take, and, most importantly, be successful at it. In this way, they can perform jobs for a number of different organizations to which they would like to make a contribution. They can do a job for an arts organization, a project for their child's school, Planned Parenthood, an environmental group, and so forth.

Contrast this approach with the expectations and needs of typical board service. For most, joining an arts board is like stepping into a black hole of unending responsibility, work, guilt, hanging by the thumbs over cash flow, and being harangued about raising too little money. There is not much chance of success and little reward.

Arts organizations will have to be considerably more sensitive to the needs of our community participants. We must develop expectations and structures to meet their needs so they can meet ours. We need to see the board not as a lump but as a group of individuals with needs, desires, and talents. If we do not find a way to individualize our relationships, we will find ourselves without volunteer leadership.

Conventional Wisdom in Conflict with Reality

Another factor that affects our thinking about boards is the conventional wisdom that has guided board development for the past twenty to twenty-five years. In 1958, in *The Affluent Society*, John Kenneth Galbraith coined the phrase "The Conventional Wisdom." He said that, in some measure, the articulation of the conventional wisdom is like a religious rite—"an act of affirmation like reading aloud from the scriptures." The conventional wisdom is not fixed; it is periodically overcome, not by new ideas, but by the march of events, which may expose old ideas as useless or dangerous. Is conventional wisdom necessarily wise? Galbraith warned that it "accommodates itself not to the world that it is meant to interpret, but to the audience's view of the world."

With regard to not-for-profit arts boards, this conventional wisdom has evolved into a pervasive body of mythology that needs to be seriously and openly reexamined. These board myths are often in direct conflict with the new realities for members of the community. Some examples of this mythology include:

Myth: *A board of community leaders assumes fiscal, legal, fund raising, corporate, and policy-making responsibility for its organization.*

In reality we are asking the board to run a business it knows little or nothing about. The whole enterprise gets off on the wrong foot. Begin with the interpretation of policy. Conventional wisdom tells board members they are responsible for setting policy, while in the next breath they are told, "But you do not involve yourself in artistic decision making. Hands off." But what is the ultimate policy of an arts organization if not the artistic vision and the work of the artists to realize the vision? All other decisions are about how to achieve the artistic choices. This myth causes most of the tensions in staff and board relationships.

Myth: *The only way to get someone to do something important for the organization is to put her/him on the board.*

We believe there are a growing number of people who will only do something important for us if they are not on the board. Also, many organizations are reluctant to exercise a board rotation policy because of this myth. They fear that if a person rotates off the board, he or she will be lost to the organization. They do not recognize that persons can help an organization without agonizing over cash flow.

Myth: *Board membership is the only recognition for service to an organization.*

We need to find a wide variety of means of recognition for appropriate services. We need to find ways in which board members' employers and community leadership acknowledge and recognize forms of support other than board service. • 37 •

Myth: *All management functions or expertise not supplied by staff can be thought of as board responsibilities.*

Board development has been based on the organization's needing legal, accounting, printing, marketing, volunteer support, etc. The practice has been to put one or more experts on the board to supply this needed information or service. This is the primary reason we have "slot" boards. When all the services the organization needs from the community are considered board functions, an enormous spectrum of activity is required by the board. The practice has led to excessively large boards and confusion about the individual experts' overall responsibility to the organization. Once their service has been provided, they believe their board function has been fulfilled. The ongoing responsibilities of the board seem an intrusion on the commitment they made. There is a lack of clarity about membership, service, and organizational responsibility.

Myth: *All the activity provided by the board should fit into one structure.*

A variety of people have been recruited for a variety of purposes, but they all sit on one board. At one end of the spectrum are dedicated volunteers who are effective at hands-on work. They are made to feel guilty because they are not able to influence the community nor are they comfortable with raising money. At the other end are men and women who enjoy leadership, influencing the community, and fund raising. They have neither the time nor the interest to stuff envelopes or put up the tables for the gala. The result is a great deal of stress, guilt, and tension among all board members.

Myth: *If we create the right institution with the right board and the right management, then this abstract lump, the institution, will provide artists with what they want and need.*

Over the past twenty-five years, arts professionals, funders, community leadership, and service organizations have put an enormous amount of belief and energy into the expectations of institutionalization. Thus the theory and practice of organizational development and technical assistance have focused on creating the organizational bubble. Institutionalization meant an ongoing structure of management and artists, permanent equipment and facilities, employment benefits, stable staffing patterns, consistent and repeated performance or exhibition seasons, annual reports, and systematic divisions of labor.

The assumption has been that if the institutional bubble were built correctly, the energy and resources of the institution would automatically flow into the center and the work of the artists.

Another assumption has been that every organization would have the same bubble—only smaller or larger depending on the organization's size. The museum, symphony, and opera would have large bubbles; the small contemporary dance company or the culturally specific theater company would have small ones. An organization's mission or discipline, the nature of its work, the company's roots in the community, appropriate size and scale simply did not matter. Technical assistance has focused on building an organizational consensus on a mission statement that is supported by the three-legged stool of artistic, board, and management functions. The mission statement has been seen as an abstract document that is designed to please everyone.

A central element of the institutional bubble has been getting the right board. This expectation has led arts professionals to abdicate the authority, responsibility, integrity, power, and accountability for their organization to the idea of the institution. If we can get the "big guns" of the community and the corporate CEOs on the board, the organization will be successful. This has raised very unhealthy and unrealistic expectations regarding roles and relationships on both sides.

We believe the institutional model was created by funding sources and community leaders as a way to insulate and protect the community and its investment from artists.

Myth: *Once we get the institutional structure right our problems will be solved.*

Arts professionals must understand that the professional (i.e., artistic or programmatic) life of an organization is a whole and the product of an ongoing process. Change is a constant; it is not a matter of going from one fixed state to another. We must keep changing and evolving. We must stop seeing new information or problems as unrelated events and stop reacting to each separately. Each professional leader(s) must develop her or his own process for planning, problem solving, and decision making. No matter what happens—a grant falls through, the artistic director leaves, we do not meet our subscription goals, or we need new board leadership—the issue must be run through the process. Out of this we can find creative, appropriate solutions that relate to the whole and grow out of each particular situation.

Myth: *If we tell prospective board members the true nature of the duties and responsibilities of being a board member, they will not come on the board.*

In the effort to recruit the right board, organizations have not been clear and specific about the mission, the work, and the expectations of board members. The hope has been that once recruited, these board members will magically transform themselves into being passionately committed to the work, to being active leaders and dynamic fund raisers. Is it any wonder we have so much deadwood on the board? If board members have a perception about what the organization is and if that perception is different from reality, they will either try to change the organization to meet their reality or become ineffective. Neither posture is healthy for the organization.

Myth: *Getting the heavy hitters, big guns, and corporate CEOs of the community ensures the organization's success.*

These are really code words for suggesting that if you get rich, influential individuals to join your board, they will raise money from each other and give it to you. "If only we would recruit these kinds of individuals, all of our problems would be solved. If we cannot, we have failed," or so this line of thinking goes. In truth, however, by concentrating exclusively on "the really important people," we have skipped over the people closest to the art—our universe of constituents. This also implies there are no "right people" in our audience. With the possible exception of a few large arts institutions, even if an organization could attract a "big gun," the organization likely could not meet her/his professional, social, and personal needs. We are searching vainly for an ideal that is inappropriate and unattainable—and raises expectations that no one can meet.

Myth: *If we double the size of the board, we will double the size of our contributed income.*

This is undoubtedly a concept that was put forward and has been perpetuated by those who have never had any real experience working with boards. We have found that most often, doubling the size of the board means doubling the work that staff must do while still raising about the same amount of money. If anything, doubling the size of the board will more than double the potential for diffusing energy and creating conflict on almost every level.

Myth: *Artists are irresponsible and emotional beings who need to be managed and protected from themselves; and conversely, people from the community are insensitive, non-creative, corporate types whose work and profession are less important than making art.*

The fundamental differences in needs and expectations of both groups have led to a great deal of destructive stereotyping that must be exposed and examined.

Choreographers need a dance company, musicians need an orchestra, visual artists need exhibit spaces, theater artists need a theater company. Lawyers, accountants, corporate executives, and community leaders do not need a dance company. They need law and accounting firms, banks, and corporations to meet their professional goals. In many ways neither group fully understands each other's needs.

The community may feel it is important that they have a ballet or an orchestra and they are willing to help make it a reality. But arts professionals need to re-empower themselves with the authority, responsibility, integrity, and accountability for their own organizations. They are the ones who truly understand their professional needs. But arts professionals cannot do it alone. We need enormous help and support from the community. We need to find ways to develop appropriate expectations, relationships, and responsibilities with our community partners.

Given today's environment and challenges, building bubbles and designing mission statements are little more than symbolic gestures that, for the most part, serve to satisfy certain funding guidelines. We believe that the artists or professional leaders must be at the center of their organizations. Positive change in an arts organization must be defined and led by the arts professionals—the artists and managers who need their dance companies, theaters, and museums.

Our professional leaders must clarify and communicate what the center is—its philosophical base, aesthetic or programmatic framework, and personality. They must then create the appropriate organization and holistic culture to serve the center.

MOVING BEYOND THE MYTHS

By exposing the myths we can see how the "march of events," how today's realities, have rendered the conventional wisdom about arts boards useless (if it was ever truly useful). This understanding

likewise leads us to certain other conclusions about organizational structure, relationships, and activities.

Back to Basics

Once disabused of myth and conventional thinking regarding boards and organizational relationships, how do we begin to rethink more appropriate roles and relationships?

1. We must begin by returning to the instructions given us by government agencies.

Reduced to its simplest tenets, the IRS states that a not-for-profit arts organization must be educational in nature and meet state incorporation regulations. State laws set the minimum number of trustees (usually three), define fiduciary accountability, and contain broad language about trusteeship. Nowhere does either the state or federal government specify large boards, elaborate structures, or who should make up the board.

If the board can meet the legal requirement by having three people, why change those three or expand the number? The mechanism that always triggers a change is a realization that the current human resources can no longer generate the financial resources to meet the organization's needs and goals. That triggering mechanism has been allowed to go unchecked and has resulted in unwieldy organizations, large in staff and large in board, that have been institutionalized beyond their capacity to sustain themselves.

2. We must eliminate hierarchical and classist thinking about the relationship between the board and staff of professional organizations.

The row of boxes beginning with the board on top, followed by the executive committee and then the staff, does not reflect the necessary interaction for a productive relationship of board and staff. This structure is even less functional when the lay president of the

board is considered to be the CEO of the organization. The hierarchy places a barrier to direct communication between the staff leadership and the board. In successful organizations the working relationship is always one of an active, dynamic, supportive, trusting, and equal partnership. The hierarchical model reinforces conflict in governance, control, decision making, and creates confusion about roles.

We have come to understand that much of the conventional wisdom and the dysfunctional relationship between board and staff is based on class. As stress develops between staff and board, class issues are revealed more and more.

- Board members work in the for-profit (read "real" world)—arts professionals work in the not-for-profit.
- Board members are well paid—arts professionals are not.
- Board members are of the professional class with training, knowledge, and expertise—the arts are not a profession and staff do not have knowledge and expertise.
- The board is the employer/ruling class—staff are the employee/working class.
- Staff members should not participate in the nominating, recruiting, and officer selection process—the working class should not be involved in choosing the ruling class.
- Class distinctions are reinforced when the staff exerts leadership in these unhealthy situations—they are rebuffed because they do not "know their place."

We are not suggesting that this relationship exits in every situation. However, we see too many examples which consistently reflect and perpetuate this thinking. It is also interesting that these issues are more prevalent in some cities than others. They are also strongly influenced by generational factors. That is, the older generation of board member, not necessarily by age but by tenure, are far more entrenched in classist ways of relating to arts professionals. The newer generation of board members increasingly expect to be led and

directed by staff. Unfortunately, in many organizations these issues also present themselves as issues not only of class, but of gender and sexual orientation.

3. All must understand that the central artistic mission or "artistic center" of the organization is the driving and defining element in all its relationships.

We define artistic center as the unique combination of the philosophy, aesthetic/programmatic framework, the person(s) at the center, and the unique culture of an organization. More specifically, we describe these elements as follows:

The Philosophical Foundation—the "why" of the organization. It describes the core vision, the need and importance of the work, and the service provided to the community. Today, the why is more important than ever. As the needs of a community grow and resources shrink, clear articulation of "why we exist" must distinguish our arts organization from the multitude of other organizations and worthy choices. To say, "We do great art, and we deserve support," is insufficient.

The Aesthetic or Curatorial Framework—the context within which artistic and programmatic decisions are made. Given the extraordinary range of aesthetic possibilities within any art form, the aesthetic framework is why a given artist(s) makes the choices he or she makes.

The Person or Personality—the person(s) at the center of the organization provides the spiritual center and is responsible for creating the work and/or selecting the programs and projects. Arts organizations are successful because of the vision and energy of the person(s) at the center.

The Culture or Values of the Organization—the commitments and beliefs, standards of work and behavior, ways of working, ways of relating to each other, and ways of relating to the community are unique in every successful organization. Everyone involved in an

arts organization must understand and share the values or they will not be able to function or contribute to the organization's work.

The artistic center is the fundamental policy of an arts organization, and from this center all other policies and procedures flow.

But who sets artistic policy? If the founder(s) is leading the organization, he/she does. If the organization has evolved to another generation of artistic leadership, it is the responsibility of the professional artistic/program leader to determine the center. Every other organizational decision flows from the center and should organically support the center.

The center, however cannot exist in a vacuum. Artistic/programmatic needs must be balanced with realistic human and financial resources, and with being of value and service to chosen constituencies. Perhaps the greatest challenge to artistic leadership is to determine the balance between serving and leading the artists' communities.

It is critical that the professional leadership and board reach understanding and agreement about the center. We use both understanding and agreement to draw attention to the fact that it can be easy to reach agreement but very hard to gain understanding. That is, it can be easy to get the heads nodding around the board table in agreement about an issue, but very difficult to reach real understanding about the ramifications of a decision. For example, it is easy to get a budget agreed to, but it can be very difficult to get the budget understood. A board member may agree to increase the contributed income budget yet not understand that he/she must participate in raising the money.

According to press stories of the spring and summer of 1991, the Spoleto Festival in Charleston, South Carolina, presents an unfortunate example of an organization that did not have understanding and agreement about its center. The Washington Post quoted Gian Carlo Menotti, "Beware of general managers and beware of boards of directors. They are ruining the arts." According to the press, there

was disagreement among Menotti, the general manager, and factions of the board and community leadership about the philosophical base (why the festival exists) and its aesthetic framework (if it is to have a specific aesthetic or one that is more broadly defined) and who makes the decisions about all of the above.

There is no room in organizations for devil's advocates. Maintaining an arts organization in today's realities is a very fragile endeavor. No one can say, "I really did not agree to the decision," and then sit back and continue to point out why it is not a good decision. This is not to suggest a group of rubber stamps. Define issues, gather research, develop options, fight, argue, and debate. But once a decision is made, each person must work to achieve the goals or leave the organization. There can be no exceptions. All energies must be directed toward the same end. Devil's advocates at best diffuse the energy and at worst are a cancer within an organization.

If artists need resources in addition to what they can generate, they must inspire and collaborate with the board, staff, and community. They cannot say, "We do great art, go get us money." It is critical that the artistic leadership fully engage with the board and staff about the nature of the work and why choices are made, and that they be responsive to the questions and concerns of their partners.

As arts organizations reach their second and third generations, we see an even more intense need for this examination and self-awareness. The most critical time in an organization is when the person or persons at the center leave. During this time of transition, the board and staff leadership are the keepers of the philosophy and aesthetic core. The first decision to be made is whether or not the organization should continue. If so, should the existing center be retained or does the organization want a different one? Once the decision is made about the framework, a process can be developed to search for someone to fill it in. As soon as the person is in place, then he/she is at the center and is the decision maker. The organization will then begin an evolutionary process under new leadership.

4. Professional staff must be responsible for directing, managing, and supporting the work of the board.

The board must be lead and directed by the arts professionals and the staff of the organization. This empowering of staff may cause some tension within the organization. The older generation of board members may be committed to the hierarchical format of conventional board thinking—the role of the board as oversight of the staff—finding 100 nifty things for the staff to do. The new generation of board members expects the staff to direct and manage their time so that it will be effectively and efficiently used. This redirection of the board's focus and energy is toward the community and generating resources and less toward managing the organization.

Many arts boards are made up of middle managers whose profession and training are management of for-profit businesses. Arts professionals then wonder why the boards have a difficult time understanding not-for-profits and want to manage the organization itself. We must redirect the energy and change the relationship.

Until the arts professional(s) claims responsibility and authority for the center, all other work is done in a vacuum and is, at best, generic. The professional leaders cannot do this alone; they need a great deal of help from other arts professionals and the community. But the expectations, roles, relationships, resources, and decision making must be specific to each organization.

Some arts professionals are secretly at the center but put energy into creating an organizational facade so that board members think that the board is at the center. Other arts professionals, although their instincts tell them they should be at the center, believe the mythology of organizational development, which does not allow them to be at the center. Some professionals need encouragement to move into the center; still others do not feel comfortable as leaders and will not go into the center. Thus, the organization remains adrift.

Putting the arts professional at the center should not be done

in an arrogant or dictatorial manner, nor does it mean replacing one hierarchy with another. But we believe that every successful human endeavor must have a knowledgeable leader(s) who can articulate the vision of the organization and engage others to share and work for that vision.

5. Staff leadership should have full voting membership on the board.

The argument that a voting staff constitutes a conflict of interest is invalid. The voting membership is a way to recognize that arts organizations are artistically centered and staff led. This thought will cause some conflict and raise the question, "But who really is in charge? Who has the final responsibility, and what about our role as trustees for the public good?" However, conventional board structure does not guarantee professional and ethical behavior. It is arts professionals in partnership with the board of trustees who must behave in a responsible, professional, and ethical manner.

We have seen too many examples of large traditional boards not exercising their responsibility to believe that this myth of fiscal trusteeship is functionally sound. For example, it was reported by The New York Times, Friday, May 4, 1990, that the Joffrey Ballet "faces a $2 million deficit, $800,000 of which is owed in payroll-withholding taxes, a fact board members discovered last month, a member said." At that time, the Joffrey Ballet had two boards of heavy hitters, one in New York and one in Los Angeles, no doubt with the appropriate number of lawyers, accountants, bankers, and CEOs.

WHERE TO BEGIN—START AT THE CENTER:
THE ARTISTIC PROCESS AS OPERATING PARADIGM

A more appropriate way of thinking about organizational structure, roles and relationships, is to examine those within the organization that work best. Ultimately an organization is successful because of the artistic work and programs it produces, presents, or

exhibits. Each group of artists and discipline has its own distinct process for making work, and this process should be the operational paradigm for everything in the organization.

The professional life of an organization could be visualized as in Figure 1.

1. The Center. At the center of an arts organization is the artist, artists, and/or professional leaders. Often this is a single artistic director or producer, but increasingly there are collectives of artists at the center. There are also examples of both artists and managers or producers who collaborate at the center of an organization. As every arts organization is different, the arts professional(s) at the center will be different. Those at the center provide the defining elements of the organization's center as described earlier on page 45.

2. The Core. Around the center is a group or an arc of people who are closely involved in creating, producing, and supporting the work. This is the "core," which can include a company, an ensemble, artist

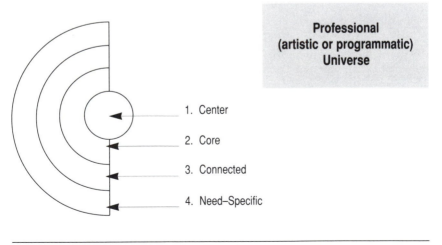

Figure 1

members, professional staff, musicians, curators, directors, designers, and technicians. The core is the first group the center considers in selecting work, projects, and programs. The organization and its center have an ongoing artistic, spiritual, professional, and, in some cases financial commitment to the core. Those in the core have the same artistic, professional, and spiritual commitment to the center.

3. The Connected Arc. The "connected" arc represents those people who have an ongoing relationship with the center, but only on an as-needed basis. These people may be involved frequently as their talents and abilities are needed to expand or augment the core. They comprise the pool of people those in the center first think of to fill additional artistic or organizational needs. The center has a spiritual relationship to the connected people but not an ongoing artistic, professional, or financial commitment. Those in the connected arc are also involved with other artists and organizations. They do not expect to have their artistic, professional, and financial needs met by the center. If new members are brought into the core, they will likely come from this pool of connected people.

4. The Need-Specific Arc. The "need-specific" arc represents those artistic, administrative, and technical personnel who fulfill the specific one-time needs of the center. Their skills and talents are generally not available in the core or connected arcs. The only relationship they have with the organization is around the specific job; there is no intention on the part of the organization to develop a long-term relationship. While in residence, however, the contribution of these individuals has a value equal to any of the others.

In the artistic life of an organization, the process, roles, relationships, decision making, and values should be understood by everyone involved. Each participant understands how all of the pieces

fit together and what they contribute to the total. Each understands the process, collaboration, and how and where each collaboration is led or directed. There is a shared vocabulary. The artistic or professional leadership will know how to communicate their process and values to each participant who joins it.

In each arts organization the center strives to create the most effective, holistic culture possible to produce, exhibit, or present work. While many professionals may be invited into the culture, only those who understand and fit into the culture will be invited back. For example, if the process requires performers to come prepared with ideas to collaborate and improvise, but a performer wants to be given direction, there is a clash of cultures and process and the person will not be asked back.

Let us contrast the traditional not-for-profit arts organizational model developed over the past thirty years with the example described in Figure 1. In the traditional model the process, roles, relationships, values, and decision making are hierarchically structured.

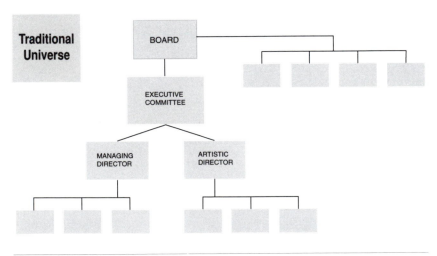

Figure 2

Now let us position the traditional structure next to the artistic example.

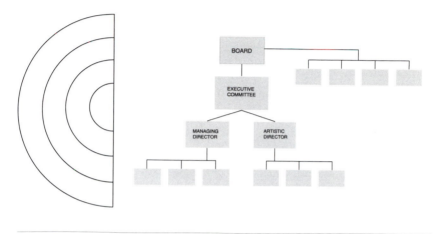

Figure 3

What is wrong with this picture? The two figures represent a clash of cultures, values, process, roles, vocabulary, relationships, goals, and decision making. A hierarchical structure is pitted against the creativity, intuition, collaboration, and values of the artistic process that drives and defines the organization. There are two cultures—artistic/professional and board. Sometimes there are three cultures—artistic, administrative, and board. Many organizations speak different languages: artistic, administrative, funding, and community. The problems of translation are enormous.

The result is that a great number of organizations create a traditional facade that looks "right" to the community, funders, and consultants, reflecting thirty years of not-for-profit arts mythology. However, behind the facade the organization is functioning the way it has to, to get things done. This guerrilla operation does not look at all like the facade. When someone external to the organization—a

funder, on-site evaluator, or community leader—looks at the organization, up goes the facade.

The energy devoted to the facade is wasted. We believe all energy must be invested such that each group of professionals can function to produce, present, or exhibit art in relationship to their community. There must be a structure, discipline, and accountability appropriate for them.

The coexistence of confusing, competing, and often conflicting cultures is the principal reason for the dysfunction of many cultural organizations. The symptoms of the dysfunction may be not raising enough money; not selling enough tickets; not producing, presenting, or exhibiting what a board member thinks the audience wants; not having the right long-range plan; or not having enough market research. The cause will likely be the absence of understanding and agreement about the center and the lack of a holistic culture that reflects and utilizes the artistic process of the organization.

CREATING A HOLISTIC ORGANIZATION: MEETING THE CHALLENGE

How does an organization begin to develop a complete, holistic culture? We believe the human resources that come to the organization from the community should mirror the artistic, programmatic, and professional universe.

The Community Core. Each center needs a core of community collaborators that corresponds to the professional core. The relationship of this core with the center will obviously have a different level of intensity than that of the professionals to the center. The arts for community participants are not their profession or life. But they share with the center a belief in the work and its importance to the community.

Most organizations already have a core of sorts but do not recognize it because to do so requires breaking down hierarchical

barriers. Arts professionals working within a traditional organizational structure will usually describe their board as follows, "We have a board of twenty-five, but four to six people do most of the work." These people are the equivalent of the professional core. There should be a real understanding, collaboration, and communication between the center and the core. There should be a long-term and spiritual relationship. Bob Leonard, producing director of The Road Company, Johnson City, Tennessee, calls these members of the community core "compatriots."

The Connected Community Arc. The center and the organization also need the arc of "connected" participants. These are the people who respond to specific jobs and tasks. These people expand the work of the core or fill needs not represented in the core. Again, this arc exists in organizations but is not openly recognized. It is usually made up of an additional six to eight board members and another set of volunteers who can be counted on to accomplish or support specific jobs or tasks of the core. They increase the number of people working on projects or take on jobs not represented in the core. They should have an ongoing relationship with the center and the organization, though one less intense than that of the core arc.

Those in the connected arc may have similar relationships with other organizations. The center is important to them, but they have other priorities as well. When asked, participants in this arc will respond to requests for specific projects if those projects meet their needs. These are the people who will produce the benefit, work in support of marketing activities, participate in selected fund-raising functions, support office work, usher, and work the front of the house—their possibilities for involvement are unlimited.

The Need-Specific Community. The center and the organization will have "need-specific" requirements from the community. As with the artistic, programmatic, and professional universe, jobs, tasks, and services will arise that are not a part of the core or connected arcs. These

could include a specific legal, insurance, or financial service, expertise provided by architects and contractors on a facilities project, computer advice, help on a capital campaign committee, or an annual fund-raising activity. Again, the possibilities are unlimited. In this arc a person is asked to accomplish an agreed-on task. The task usually has a specific time frame, and when the job is completed, the person has made a contribution and is suitably recognized and thanked. There is no expectation of an ongoing relationship. Patty Lynch, when she was the producing director of Brass Tacks Theatre in the Twin Cities, called these participants "individual action units."

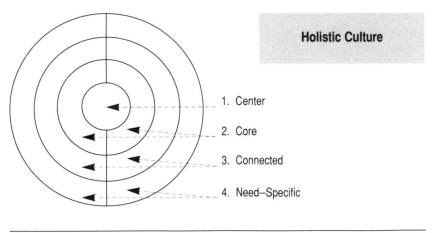

Holistic Culture

1. Center

2. Core

3. Connected

4. Need–Specific

Figure 4

Maintaining a Dynamic Culture

People should move through the various arcs as their interest, time, and level of commitment correspond to the needs of the center. A need-specific person may become intrigued by the organization and want to do more and become "connected." A core member may no longer be able to maintain his or her position in the core because the center's needs have changed, or their interests have changed, or there has been a change in their professional or family life. They would be

better served by moving into the connected or need-specific arc. This kind of movement should be encouraged and directed by the center.

Often there are board members at the need-specific level of participation who are not thought of as contributing members of the board. The center may not be aware of the limited contribution and commitment these people are capable of making, yet they are kept on the board in hopes they will be miraculously transformed into core participants.

Applying the "Casting" Metaphor to the Organization

The way to start creating a community universe that mirrors the artistic universe is for those in the center and artistic/professional core to envision all of the services, tasks, and jobs that need to be done by the community universe. They then should put all of the organization's energy into identifying people to do the jobs, creating the appropriate relationships, and getting the work accomplished. Energy should not be wasted on board development. We must focus our energy on what the jobs are and how we can get the work done.

Every center needs a core group of people from the community who are closely connected to the center. This core could end up looking like a board or even be the board—or the center could be the board with community collaborators working in support in different configurations.

We suggest using the casting process of the performing arts as the metaphor for organizing the community universe to get the work accomplished. Directors recognize that as much as 70 to 80 percent of the success of a production depends on the casting. If a director casts well, he or she is a brilliant director. If a part is miscast, the actor must be replaced or the production will not be successful.

The play determines the parts to be portrayed, and actors are auditioned for the parts. We know we are casting a wide range of roles—leads, character people, walk-ons, juveniles, and ingenues. Each part is necessary for a successful production. We hope to cast the

right actor in the right role and then rely on the director to direct and support the actors so they can be successful.

Within the community universe, the center must determine all of the jobs/parts that need to be accomplished, identify and audition people who are capable of accomplishing the work, cast the right person in the right job, and then appropriately direct the person so he or she can be successful.

Part of the casting will be to put the person in the arc most suitable to both the organization and to the person. Those in the core play the leads; the connected arc is made up of the supporting players, and the need-specific are the walk-ons. As in the play, each role is critical to a successful production.

One of the critical issues facing all not-for-profits is scarcity of human resources. Where are our potential human resources? They are in our universe of audiences, members, and in our classes. They are not outside of our constituency. If we begin inside, they already know us, we are important to them. We don't have to convince them of our value and try to interest them in the work we produce, present, or exhibit. We need to get to know our friends and explain our needs and ways they might help us. If we identify a need that cannot be met by someone in our universe we should identify prospects who might fulfill the role. Then we must conduct a cultivation process to see if we have shared interests and values and if the person will make an effective contribution to the organization.

A goal of creating a holistic culture is to eliminate the line dividing the professional and community participants in the core and connected arcs. The organization must always work toward a single holistic culture that encompasses the center, the professionals, and community participants. Every organization has a culture, whether or not it is acknowledged. Organizations that have two or three cultures that compete or clash with one another are destructive to the whole. If we develop and pay constant attention to our holistic culture, we will have much more effective and healthy organizations.

We need to invite people into the culture, but not simply to fill boxes and job descriptions. Only people who understand the culture and want to be a part of it will be successful and productive in it. If a person does not fit into the culture—or if that person does not "get it"—they will not be effective and may try to change the culture to fit their own needs. This understanding of the culture must apply to everyone—artists, administrators, board members, and volunteers. No matter how experienced or talented, if a person does not "get it," he or she will not be successful. If we make a casting mistake and the person does not have a connection with the organization, that person must leave the organization.

In the artistic process if a person is miscast and the function is critical to the success of the production, the role must be recast. Likewise, if a person does not fit in the culture, yet her or his function is of lesser importance, that person may be allowed to fulfill the specific function but then should not be asked back.

Unfortunately, organizations do not make changes in their community universe if a person is miscast or does not belong in the culture. Organizations tolerate ineffective board members who often try to impose their own agendas or gain professional and social benefits by being on the board without giving anything.

To cast people in the community core, the center should select the four or five most critical needs of the organization from among all of the tasks, jobs, and services to be accomplished by the community members. Meeting these needs should be the mission of the core. This allows the center to typecast community collaborators who are comfortable with and can complete the tasks. All of the other jobs will be in the connected or need-specific arcs and will be done on an individual-task basis.

The identification of these critical issues must be organically developed by each organization and will change as needs change. The spectrum of possibilities is quite broad. We have worked with a touring company whose producing director is the only full time

professional staff. She also creates the work for the company. Her needs of the community core are for people to perform the day to day management functions. She selected a small group of people she trusted to keep the books, do the marketing and grant writing.

A Leadership Core

If an organization determines its critical needs are to increase visibility and raise contributed income, we recommend narrowing the focus of the board's responsibility to leadership.

Leadership consists of:

- articulating to the community the mission, the role, and value of the organization;
- influencing community participation in the giving and raising of contributed income;
- identifying needs and cultivating human resources; and,
- providing fiduciary accountability.

In response to the need of the community leadership to be task-oriented and to have their time effectively and efficiently utilized, narrow the focus to these four responsibilities. In this way not all the organization's needs from the community are included within the core structure.

The Leadership Core Defined

A. The core must understand the center.

Influencing the community means first understanding and supporting the center and goals of the organization. Everyone in the organization must be unqualified about and work one hundred percent in support of the mission and goals of the organization. Influencing means educating, communicating, positioning, and cultivating the community or communities at every appropriate level in the vision, goals, and needs of the organization. Everyone can and

must be a dedicated and passionate influencer of the community. There is no one who cannot effectively influence the community if they understand and believe in the organization. One of the tests for a board member, as well as anyone in the organization is: could they answer any intelligent question about the organization?

As the attacks by the religious right against the arts community and free expression continues, board members will increasingly be challenged about their belief, commitment, and support of their organization. There cannot be too much attention paid to communication and understanding of the center, direction, and programs of the organization. This effort does not require "heavy hitters" or "big guns" but people who are connected to and passionately dedicated to the success of the organization. We must decide who we want to influence and then craft an ongoing plan, timetable, and materials to be successful in this effort.

B. The core must generate contributed income.

Everyone in the core must work to achieve the contributed income goals by making a personal contribution and participating in the fund raising program. This is perhaps the most difficult and least understood area for a board. While every board member must make a personal contribution we do not advocate a head tax, meaning every board member must give a fixed sum. For some people, a $50 gift might be significant. For some people a $5,000 gift is appropriate and we would let them off the hook by a lower requirement. In approaching corporations, foundations, and outside individuals, we do our research and ask for an appropriate amount. Why would we treat fellow board members with less respect by not following the same process? Only by analyzing each board member's ability to give and soliciting a specific gift can we intelligently budget and structure board giving. What is important is that each board member make a contribution and that the board is giving at one hundred percent of its membership. Every gift has equal value to the organization: $50, $500,

or $5,000. A contribution by a board member's firm does not count as her or his personal contribution. Each person must make a contribution and also participate in fund raising activities, which may include soliciting from their firm.

We advocate extending personal financial contribution past just a board responsibility. That is, we believe every person involved in an organization should give a contribution—staff and volunteers. This may create a strong response from staff members who feel they are overworked and underpaid as it is, and, as a result, are subsidizing the organization. This may be true, but how can we go to our boards, audiences, and the community for their support unless we have demonstrated financial support for the organization we need to meet our professional and personal goals? Board members are certainly giving of their time. How can we ask them to also give money without a similar sacrifice of our own? It is very impressive to look at donor lists in programs and identify the support for the organization that is coming first from within the organization. This approach brings arts organizations into the fund raising thinking of other nonprofits such as universities and organized religion.

Most board members do not participate in, or are afraid of fund raising because of a lack of success in previous experiences. Board members have been set up to fail. Most board fund raising follows this scenario: "We need money. Corporation X or Mary Money has money. Sam, go ask for it." There is absolutely no logic that brings together our need for money with someone's ability to give money. Too often fund raising is in a vacuum without a context, and as a result the board member's efforts have been unsuccessful.

This approach to fund raising is chit-for-chit fund raising. The person is calling in chits, using personal relationships. Contributions are being made to the person and not the organization. The person also knows that for each chit called in, they will also have to respond by giving to the person they asked. This chit fund raising has created the pressure for an organization to get chit players on the

board, usually characterized as "heavy hitters." Most organizations do not have the ability to attract chit players because of the nature of the work, or because the group cannot meet the social, personal, or professional needs of the players. As communities' needs grow and resources are stretched further and further, chit fund raising for the arts is less and less a reality.

Every board member has the responsibility to identify sources for contributed income and to cultivate those prospects. Cultivation means seeing if we can bring together our need for money with the prospect's ability to give. Is it possible to find a common ground of values, need, and interest between our need, and the prospect's need? Everyone on the board must be an identifier and a cultivator of prospects. Who eventually asks for the money becomes less and less a factor. This also goes back to the complete agreement and under-standing of the mission and goals. A person can be an active and dynamic cultivator only if he/she believes in and is passionately com-mitted to the organization.

If a board has members who are chit players they should be fully supported and recognized. In this case there should be two fund raising environments and structures. Usually chit players do not want a great deal of structure, do not want to attend meetings or follow a plan. They will make their calls at their convenience with appropriate prompting by staff and board leadership. A process must begin to cul-tivate a direct relationship between the donor and the organization.

Members who do not have the personal contacts or are not strategically placed in corporations need a well-structured plan and direction in identifying and cultivating prospects. Both environments are absolutely critical so that each board member's needs are met and they can be successful. If the non-chit players do not have the second environment they will feel intimidated and will not participate in the process. The goal is for each person to participate within their ability. If so, everyone's participation has equal value.

Big guns and heavy hitters who are on the letterhead but are

not involved cannot or will not lay it on the line for an organization. This search for the big gun has led us to skip over the people closest to us in search of an ideal that raises expectations that cannot be met. When we have not attracted these individuals we feel we have failed.

There are no new or innovative short cuts in fund raising. It is a process of determining needs, doing research, identifying of prospects, cultivating, and soliciting in a carefully constructed and well-managed program. Fund raising cannot be chit playing in a vacuum but instead must be about realistic needs and developing the appropriate relationships.

C. Identifying and Recruiting Human Resources.

Human resource recruitment is the most critical function of the core and staff. Only if recruitment is successful can the human resources evolve and grow to meet the needs of the organization. Recruitment should be thought of not only in reference to the core, but to all the organization's needs from the community. We must replace the old board nominating thinking, which is basically to find more people just like us. We must begin to see this activity as human resource development for the entire organization.

If nature is allowed to regenerate, it improves and positively responds to the environment. The problem with most recruiting and nominating is that it focuses on replacing the current board. As a result the board and committees we had three years ago are virtually the same board we have today and will have in three years. Instead, the process must be to determine the future needs of the organization, to identify prospects, and then cultivate those prospects to determine if there is a mutually beneficial reason to invite them to serve the organization. We must be crystal clear and specific about the artistic vision, the nature of the work, the expectations, responsibilities, and the nature of the decision making process.

The organization's search for new community members should be based on finding persons who know and believe in the

work and for whom it is important. We often do not know our constituents and skip over them in search of the "really important" people. The recruitment process must also evaluate the performance of current members. Is each person fulfilling her or his responsibility in a positive manner? If not, why not? How can he or she be helped to become productive members? We must become much more rigorous in this assessment and position non-contributing members in other places in the organization where their service can be used.

The process of recruitment must be a shared activity of staff and core. While traditional thinking dictates that staff should not be involved in the cultivation of community members and selection of the core leadership, staff *must* be actively and equally involved with the casting of their community partners.

The question of broad-based community representation on a board is very complex. There is a perceived tension among the needs for influence, fund raising, and the board to be representative of the broad community.

The make-up and structure of the board must be driven by three things:

1. the philosophy and aesthetic core of the work;
2. the segments of the community with whom we want to communicate; and
3. the appropriate expectations of organizational size and scale in balance with the human and financial resources within our universe.

If these guiding principles are applied, then the board will reflect the community the organization wants to serve.

It is necessary to educate funders and community leaders in what board make-up and structure are right for each organization and not to be pushed toward some inappropriate model. If the large institution's mission is to serve the largest possible audience, then the board must reflect that large community. An organization whose target is to serve a particular community must be represented by that

community to build effective relationships with it. A dance organization whose purpose is to produce the work of a specific artist will also have a specific community that needs to be reflected in its organization make-up. Cultivating segments of the community that should be served should be a major focus of recruitment.

D. The board's financial responsibility.

The fourth and final requirement for any board is fiduciary accountability. This is the one responsibility that is specified in the law and cannot be abdicated by board or staff. This should be one of the most effective tasks for staff and board because it is the most tangible area of the organization and yet it is often the place where there is the least responsibility taken. A great number of arts organizations are not behaving in a responsible manner, evidenced by an absence of orderly systems, of financial planning, reasonable controls, or realistic income projections, resulting in debt increasing at an alarming rate.

The Board Leadership

The size and relationships of a board should determine its structure. The board and staff can plan and implement strategies as a team, or a committee of the whole. A large board might have a fund raising committee, with subcommittees to serve appropriate fund raising activities; a nominating (human resource committee) committee; and a finance committee. The chairs of the three committees with officers could constitute an executive committee. Instead of a planning committee, staff and board members who are responsible for evaluation and operation in functional areas would also accept planning as a part of their responsibilities. The facilitation, coordination, and compilation of the planning would be through staff leadership and the executive committee.

We need to think about dividing the guidance of the board into more than one position. What is asked of the leader of a board today, in terms of responsibility, work, and time is extraordinary. The

spectrum of activity is enormous, ranging from being a community presence to making sure the board is functioning. Very few single individuals have the talent, time, or the interest to meet all the requirements of a leader. The leadership could be divided into a chair and a president. The leadership team would consist of the chairperson, the president, and senior staff, working in partnership.

The profile for the chair would be the most visible person from the community that the organization could attract, assuming that person is not a figure-head. The chair's focus could be in major fund raising and board recruiting—a Mr. or Ms. Outside. The president would be more the inside person responsible for the day-to-day operation of the board. The two people would never succeed each other. The positions require very different casting—skills, personality, and needs. They would also not rotate out of their positions at the same time in order to supply leadership continuity. With a single leader, if we make a casting mistake, there is little option but to live through a leadership vacuum. With co-leaders, a vacuum in one position can be filled to some extent by the other.

As the need for leadership increases, more and more community leaders have become reluctant to take leadership positions. Perhaps, however, if we approach people to do a part of the job, the part they enjoy, with a specific time commitment and goals, people may respond more favorably.

Board Member Requirements

Every organization needs to decide what responsibilities it wants to require of its board members. There are some obvious ones, such as buying season tickets, attendance at meetings, committee service, participation in and bringing people to the organization's activities—performances, events, and benefits. Whatever the choices, they must be spelled out and agreed to in advance. The mission of the organization, duties and responsibilities of board members must be discussed and agreed to in the cultivation process before the person is

asked to be a member. We must never assume that a prospective board member's perception about our mission and requirements are the same as our reality. A board orientation session is too late to gain understanding.

Accomplishing Other Tasks

All other expertise, services, and support should be supplied by task forces, individuals, and committees of the connected and need-specific arcs which surround the center and core. Bridges and relationships would be developed between these individuals and groups and the appropriate staff and/or core function. These tasks and jobs would meet the needs of community volunteers with limited time, offering job-specific opportunities to help the organization but not requiring a commitment beyond their need, ability, or time. Examples of these activities already exist. In many cases, special events and galas are produced by special committees that come together for a benefit and disband after completing the function. Many of the individuals will go on to produce events for other organizations; they simply like to give parties. With the current mythology, every time a need presents itself, the solution is to expand the board. A working group outside the board in partnership with appropriate staff and board will be more effective. Legal work does not necessarily need to be performed by a board member. An attorney might want to work with the organization but may not want to have the ongoing responsibility of full board service.

Very critical needs, such as capital and endowment campaigns, can be led and supported by non-board members. These chairs and participants will often agree to take on the responsibilities only if they do not have to be on the board.

We do not propose a marketing function on the board. If the staff needs professional expertise, then develop a task force to respond to the specific need. As these needs change every year, so the advisors need to change. Perhaps this year we need research, next year help in

repositioning in the community, and the next, re-imaging. Having the marketing function on the board creates more confusion. It requires board members to be experts in one more area and distracts from the leadership responsibilities. Also, a marketing committee runs the risk of believing its assignment is to find a hundred new nifty ideas for the staff to do, as opposed to being a resource for staff.

If a board member also wants to work on a task force, great. But no one is required to do so. Obviously, task forces can be a source for new board members. They will have proved their service, belief in, and commitment to the organization. The task force approach also serves a rotation policy. A board member can make a significant contribution to the organization by performing a task or service during the period of her/his rotation off the board.

If appropriate, some of the task force activities and functions carried out by the staff and board could be structured into volunteer groups or guilds. We would suggest as little structure as necessary. All of the professional, community, and personal pressures on board members are the same for volunteers. Most volunteers do not want structured meetings. They want to be effectively and efficiently utilized, to be of value, and to be recognized. There may be some volunteers who want and need structure and social opportunities. If so, that should also be available. We have seen large institutions that have as many as six different structures to meet volunteer needs.

The management of these task forces may seem an impossibility for an already overworked staff and board leadership. But it will not take any more time than we are presently putting into the current board and volunteer system without a lot of success. As people accept very specific tasks appropriate to their need and experience, they may assume greater responsibility for their success and require less direction. As they assume jobs, they may do their own casting to bring their own workers to help, thereby increasing the number of people contributing to the organization without the staff or board finding them.

In the performing arts, artists are never made to do something

they cannot do. If the performer is blocked, exercises are used to try to free up the artist. Ways may be found to work around the problem, or the circumstances may be changed. If solving the problem is absolutely critical to the success of the production and the performer cannot adapt, it may be necessary to replace the performer. Unfortunately, we are constantly asking board members and volunteers to do something they simply cannot or will not do. We must apply the same artistic approach throughout the organization. We must try to cast the right people in the right roles, and then work with them so they can be successful at doing what they can do. We must also make changes when the casting is not right.

Gauging and Recognizing the Work

It may be that every organization is attempting to do too much—trying to accomplish every possible task and good idea without establishing priorities. The result is a feeling of trying to be everything to everyone and perhaps ending up not being very much to anyone. The staff and board leadership must agree on the essential priorities and invest appropriate human and financial resources in achieving their success. All of the other needs, as important as they are, should be added to the "to do" list as human and financial resources become available. This approach will improve the quality of the work, address burn-out, and more effectively manage the human resources.

Forms of recognition must be built into the system. Generally, arts organizations are not very good at recognizing human and financial contributions. We can be somewhat arrogant in thinking we do great art and so we deserve support. As the community's human and financial resources are being stretched, and if we are going to continue to share in those resources, they must be effectively and efficiently utilized and appropriately recognized.

Board Size

In rethinking board and volunteer support the leadership of

the organization must look at the tasks which need to be accomplished and then determine which of those functions are appropriate for the board and which are appropriate for volunteers. We need to focus narrowly the work of the board into a limited number of responsibilities instead of the board being responsible for all functions for which the staff does not exist. Therefore, instead of the board being experts in everything, we ask them to be experts in a few functions. All the other needs of the community can be supplied by individuals, committees, and task forces. This division of labor between the board and volunteer support will allow us to work with smaller boards.

Given this configuration of a narrowly focused board and volunteer activity, how large should the board be? The easy answer is: large enough to do the job but not so large that it is unmanageable. If we are able to focus the board's responsibilities to a limited number of functions, then we can move toward smaller boards.

We do not believe in advisory boards. They are often deliberately misnamed. The organization really does not want advice but fund raising, and that is not clearly spelled out. An advisory board is one more structure that requires time and energy. It is human nature that people are more than willing to give advice when asked. We do not need a structure or ongoing commitment to do this. If an organization is going to have some form of a group to work on its behalf or in recognition of support it should be appropriately named and charged with its responsibility.

An Approach to Board Meetings

Most board meetings are a series of committee and staff reports in a "dog and pony" format, or some topics are endlessly rehashed from meeting to meeting without resolution. Or, a lot of good ideas are developed for the staff to accomplish while the board attempts to micro-manage the organization.

Is it any wonder we have low and inconsistent participation at board meetings? When organizations are in stress, it is almost

impossible to get a quorum. Overextended board members simply stop finding time in their lives to hear reports that they will receive in the mail a week later. Why should we gather together bright, talented and informed people from the community and not utilize them in an effective and productive manner?

Board meetings should be reconceived to focus on topic specific agendas or mini workshops. The topics could include:

- next year's season, why we have made the choices we have;
- how a season is chosen, what are all of the influences;
- a workshop on the budget, not to get it approved, but to understand it as a philosophical document;
- a workshop on the fund raising plan and strategies;
- a discussion of each of the organization's programs;
- a discussion of the organizations community or education activities and why.

This is a way to engage with members of the board, to inform and evaluate what we do. It is a way for our community collaborators to gain insight and to bring them closer to the center.

The Rewards

Given all of this information about boards, what is the reward for the board members? People are not fulfilled by attending meetings, hanging by their thumbs over cash flow, and being harangued about fund raising. A board member is successful when he or she believes in the value of the organization and is passionately committed to its success. The reward is seeing that the needs are met and the goals achieved. The person's psyche must be fed by being close to the center, to the artists, and to the work itself. It is the responsibility of the artists to inspire the board and staff to share the excitement of creating the work. This is not by choosing plays or ballets, but by understanding why artistic decisions are made, how artistic problems are solved, and being close to the process. Artists cannot isolate them-

selves in a closed world if they need human and financial resources. Artists must accept responsibility for articulating and communicating their work within the organization and to the community. They must be active leaders, participants, and partners within the organization and in the world in which they work and live.

In today's world, organizational development can no longer be the way it used to be or the way we were told it ought to be. We must understand and participate in the world around us, define and articulate the center of our work, identify the segments of the community with whom we want to communicate, and develop the appropriate size and scale of our organization in balance with realistic expectations of human and financial resources within our universe. An organization can then create roles, relationships, a decision making process, and a structure that will organically serve the center.

Because of the wide range of challenges facing arts organizations today, stabilizing and strengthening an organization is an increasingly difficult undertaking. Our concern and intensity about organizational dysfunction, human deficit, and financial survival lead us to this conclusion:

In the matter of organizational stability, every idea that is proposed must lead directly to human and financial resources. There are a hundred good ideas that come over the horizon every day. If an idea does not lead to resources, it should not be considered. If a person cannot assist in gathering human and financial resources, he/she cannot be at the table. Human and financial resources are broadly defined. It is a very large arena for people to be successful, to make a contribution. It is inclusive, not exclusive. This change must represent a way of thinking that describes the urgency, the need to direct positively the energy of everyone in the organization.

TWO ESSAYS

In the original *ARTS BOARDS* publication, a number of arts professionals were invited to provide essays expressing their thinking, questions, or thoughts on organizational decision making, boards, and leadership. Two of these essays continue to resonate strongly with us, our work, and experiences. We are very grateful to Benny Sato Ambush and Miriam Abrams for allowing us to include these essays in this publication.

Nello McDaniel and George Thorn

REMOVING THE VEIL

Benny Sato Ambush

"After the Egyptian and Indian, the Greek and Roman, the Teuton and Mongolian, the Negro is a sort of seventh son, born with a veil, and gifted with second sight in this American world—a world which yields him no true self-consciousness, but only lets him see himself through the revelation of the other world. It is a peculiar sensation, this double consciousness, this sense of always looking at oneself through the eyes of others, of measuring ones soul by the tape of a world that looks on in amused contempt and pity. One ever feels his twoness—an American, a Negro; two souls, two thoughts, two unreconciled strivings; two warring ideals in one dark body, whose dogged strength alone keeps it from being torn asunder."

These prophetic words written in 1903 are as potent and revelatory today as they were when first penned by the eminent W. E. B. DuBois in his seminal masterpiece, *The Souls of Black Folk*. They describe dichotomous dilemmas which impact the psychic, social, ethical, economic, and political spheres of African-American life. By extension, I posit that the dynamics of these dilemmas often beleaguer one of the principal institutional partners in professional African-American theaters, lay community volunteers who function as board trustees as they relate to the other key institutional theater partners are: 1) the staff/artists who create, build and operate ongoing theater institutions, and 2) the communities being served by the theater.

Confusion emanating from these dilemmas can generate dys-
functional, inappropriate behavior among those involved in the inner
circles of African-American theaters that can retard or cripple their
progress. All three partners often end up as casualties. To achieve
institutional longevity, these pathologies should be avoided.
Understanding the root causes of these dilemmas and examining
alternative paradigms more closely aligned with what is natural to
African-Americans may be requisite prescriptions for the long-term
health of African-American theaters.

In service, then, of redefining from the cultural particularity
of African-Americans both community leadership on boards and an
African-American theater's relationship with its community, I will
draw heavily upon personal experiences accumulated during my
eight-year tenure as Producing Director of Oakland, California's, first
and only resident professional theater, the African-American Oakland
Ensemble Theatre (OET). Arguably, what happened in Oakland has
parallels in the life of other African-American theaters operating in
predominantly black communities throughout the nation. My con-
clusions, though mine alone, may have relevance to many African-
American theaters and their communities.

THE COOKIE CUTTER

For years prior to coming to Oakland in 1982, I was an ardent
student of what I thought was an across-the-board model of an
American professional, not-for-profit, institutional regional theater.
That model required a board of trustees drawn from the community
to serve as a critical ingredient in a theater's stability. These trustees,
so the model dictated, ought to be noted pillars of that community
possessing a stature of public respect. They would be prominent
members of the social class and of the corporate/business community.
Their various expertise, political and social influence, and ability to
manipulate resources and direct them toward the theater would be
offered gratis to assist the theater's professional staff in managing the

affairs of the institution. Their middle-class and upper-middle-class standing would enable them to give personal cash gifts annually. They would also raise significant amounts of contributed dollars yearly from two major sources: other prominent monied community members inspired by their personal giving and the brotherhood of private sector enterprises. In both cases, the donors' largesse was a measure of their goodwill in the community.

These trustees would feel good about holding the public's trust while serving and would enjoy the privileged status in the community their magnanimous volunteering provided. Their individual egos would be satisfied by knowing they had contributed to the nurturing of an institution greater than any individual, one that would survive long after their tenure with it had ended.

My attempts to communicate these responsibilities to most Oakland/Bay Area community members, largely African-Americans, who became at various times board members of Oakland Ensemble Theatre, became an endless exercise in frustrating futility. To be sure, virtually all trustees past and present of OET were and are wonderful, well-intended folk. Training them with leadership skills appropriate for the not-for-profit arts and getting them to "act right" by following this model were never fully realized. I had struggled for years with an inept form of board governance before I understood that the reasons for these difficulties in my situation in Oakland were rooted in a spiritual and perpetual malaise that often affects my people's self-image and judgment.

I was befuddled by my board's pattern of misguided pettiness, in-fighting, cannibalization, social and psychic self-immolation, and paralysis that characterized the group consciousness of each new generation of OET's board leadership. As the theater's Producing Director and primary staff/artist, I bore the brunt of the fallout, although the generic target was the entire staff of artists, administrators, technicians, and designers.

IMBALANCES

Through me, the staff/artists were viewed by the board leadership as their subordinate employees. Our fluid, cognitive, intuitive natures were frowned upon and held suspect. We were told that we were there to be managed and directed by the superior prowess of trustees whose business backgrounds ordained them with the right of governance. My countless submissions to trustees of articles and essays from industry experts on models of board/staff relations with shared responsibilities did not persuade them otherwise. These documents went largely unread, were largely misunderstood—if read at all—and were often ignored. Trustee attendance at public board leadership seminars and professionally facilitated retreats bore little fruit. Even the multi-year National Endowment for the Arts' Advancement Grant Program process—one which focused upon strong board development—did little to improve what had become in their minds a kind of "talented tenth" entitlement to rule.

Staff's resistance to this dominance led to cyclical recurrences of dysfunctional behavior within the theater. The staff and board were not a family. We would perpetually disagree about roles and responsibilities. Expectations clashed and confusion was widespread. Crisis management was the rule of the day. Board enlightenment crept at a snail's pace. The board and staff combatively pointed accusing fingers at each other from across a widening gulf of mistrust and miscommunication.

The lack of collective understanding was no more pronounced than during cash flow crunches when the theater's future seemed most threatened. Those were the times when finding scapegoats appeared to be more important than collective problem solving. To the frequently posed question "Who is leading whom?" came conflicting answers. Hence, the fiercest battles were drawn along perceptions of entitlement, control, and power over decision making.

At OET, the contradictions grew to such destructive proportions that in May/June of 1989, a unified staff, through a complex

series of carefully orchestrated maneuvers, compelled all but two trustees then in office to resign en masse. Staff wanted to create the opportunity to build a new board and restructure a more productive relationship among the institutional partners by cleaning house and starting all over. We believed that all other options had long been exhausted and thus exercised this drastic measure to salvage the institution from wholesale implosion.

A THEORY

Time and distance have enabled me to review the record and posit some ideas regarding our impasses. I believe the myths and expectations about leadership the OET board held during my tenure were derived from a Eurocentric ambience and a not-for-profit structure which was and still is inappropriate to the cultural traditions, historical contexts, and current realities of African-American people. The natural determinants of African-American culture reaffirm in familiar terms our sense of peoplehood. When we as African-Americans abandon those determinants, as was the case with the Oakland Ensemble Theatre board, and in its place adopt a Eurocentric personality, we subvert our ability to see ourselves clearly as people. From this unsuitable frame we derive inappropriate strategies that contradict our truer selves and give rise to odd behavior. It was a misplaced self-image that put the African-American OET board volunteer smack dab in the middle of the double consciousness dilemma Mr. DuBois so eloquently described above.

One root source of the problems may in part be class-based. Most of the community volunteers who became trustees of OET were middle-class African-Americans, although there had been several white members through the years. Most had been working in middle-management corporate positions in such large firms as IBM, Xerox, Bank of America, Kaiser Aluminum and Chemical Corporation, and AT&T. Others were employees of large law firms and comparable government or public sector bureaucracies. This was the composition

of the small board that I inherited in 1982. Through the years, despite constant pleading on my part to open up recruiting, the board replicated itself over and over by accepting clones of themselves from their same small socioeconomic and racial circles. Recruitment had no process, criteria, or guidelines other than knowing somebody who was willing or got talked into serving. Sophisticated recruiting procedures offered by staff were summarily dismissed by board leadership, who presumed they knew best. Potentially helpful candidates with different backgrounds, more elevated public profiles, and stronger power bases than those of the existing trustees were branded dangerous outsiders against whom great caution was exercised. This was considered necessary to keep the institution from being polluted with the wrong element. A sameness of board membership was deemed of paramount value.

I believe this behavior was the outgrowth of the OET board's adoption of a system of thought foreign to its basic nature. These community volunteers developed their job careers and thus their sense of business largely in Euro-American corporate environments where typically the work culture is guided by a perceptual framework that sociologist Dr. Calvin Hicks has called the "World of View" tradition, a tradition he contrasts with "World of Event." From the "World of View" consciousness, the OET board imaged itself and subsequently perceived its leadership role accordingly, which then determined its conduct.

Essentially an outgrowth of Western post-romantic historicism, World of View thought embraces hierarchical power relationships, is technologically based, is pragmatic, relies heavily upon print and visual media, is static, refractory, individualized, analytical, linear, and manipulative. It assumes as the natural order of things that some must lead and the rest must be led. Leadership controls a situation, exerts its power over it, dissects it, analyzes it, demands a course of action to be followed by those lower in the chain of command, and manages its outcome. Success is measured by leadership's

ability to get done what it demands of others. Relationships with others are thus determined by how they can be used to service the needs of leadership.

This kind of thinking is the tradition in American business. It follows that its tenets were so fervently embraced by the prototype OET board member whose job success in climbing her/his corporate ladder depended upon how successfully the workplace game is mastered. Nearly all of OET's board members during my eight-year tenure had had prior or concurrent experience with boards of various non-profit community organizations, many social service in nature. None, however, had prior experience with professional arts organizations. In their other board experiences, World of View thought was accepted practice. After all, it was their model that was used to govern the for-profit boards at their places of employment. Efforts to explain how different the not-for-profit arts world is from the for-profit world or even other not-for-profit situations could not shake their faith in World of View thought. Their sense of responsible oversight dictated that they must rule the affairs of the theater. It was "the" system learned from and validated by what meant most to them, their corporate jobs.

Accordingly, the OET trustees deduced that they were in charge of the theater. As staff/artists, our creative, albeit puzzling, talents needed guidance from trustees because by our very nature we were thought by them to lack the right kind of business acumen. The sense of patriarchy inherent in World of View thought requires that the less developed right-brain-oriented staff/artists be directed by the superior left-brain skills of World of View thinkers. Since scientists and politicians do not refer to artists to solve problems, as World of View thinking goes, artists must be led because their contributions to the important matters of the world are undervalued. And since OET's staff/artists could not measure up materially (high personal incomes, homes, Benzs and other such worldly possessions), the disparity provided more evidence affirming the boards acceptance of a rightful

ascendancy over us.

No wonder it took me years before I "earned the right" to be a board member with them. No wonder most board presidents viewed as my principal priority enhancing their public posture. I now know why my harshest criticism from trustees was my lack of proper deference to them. I see why they felt it was my responsibility to make them feel good about their board involvement. I see why the considerable collective professional experience of the OET staff meant nothing to them because it was experience in areas they did not respect, nor trust, nor understand, nor cared to understand. To them, my failing was in my inherent inferiority because I was an artist. I was expected to submit to their higher thinking and didn't. Their assertion of rule was in their eyes the exercise of responsible board leadership.

This situation was, of course, ripe for conflict. Theater artists, by the very nature of their collaborative creative processes, are attuned to a radically different system of thought. This is especially true for arts organizations born out of the needs, impulses, and initiation of the originating artists. This orientation, which is the polar opposite of World of View thought, is called, again according to Dr. Hicks, World of Event thought. I would reason that World of Event thought is also the modality most familiar to the African-American. It operates in natural circumstances when our sense of peoplehood is most obvious and harmonious: in our churches, when we party, in our common social gatherings, and in head shops, night clubs, neighborhood playgrounds, and on street corners. The absence of this body of thought as an operational ethic in the group consciousness of the OET board was a primary cause of the theater's relational dysfunctions.

World of Event thought is exemplified by a non-technological social order that embraces symphonic relationships. Its work culture is horizontal or spherical in nature rather than hierarchical, more reliant on oral transmission than the written word, more functional than analytical, and sees power as a tool for effecting change rather than as a vehicle for dominance. Leadership is a collectively dynamic

process which synthesizes the collective human experience of all participating parties. Authority rotates according to the demands of the circumstances at hand. Knowledge is respected regardless of its source, and is more likely to come from those with core direct experience. Openness and tolerance are honored values, and intuitive factors hold sway along with empirical data. We is a more prevailing notion than me.

World of Event-ness is a different perceptual framing than World of View-ness and is culturally based. The tenets of World of Event thought were the survival tools historically used by African-Americans as they learned to cope with the hostilities of the New World. They remain a viable social and cultural ethic in many situations familiar to today's African-Americans. This is especially true for the only true institution that African-Americans own, the black church. It is strongly evident as well in the governing principles of black fraternities, sororities, highly organized social organizations like the Links, and with historically black colleges. Although clearly defined leadership does exist in these examples with hierarchies of sorts, a communal ideology binds the participating members more so than the exploitation of personally aggrandizing opportunities.

When it came to the business of running the Oakland Ensemble Theatre, the African-American board leadership chose to forsake what is most deeply felt, World of Event-ness, in favor of the Eurocentric-based World of View-ness. I call it a choice because on a social level outside of board meetings, board and staff often reveled in World of Event-ness. The rules switched dramatically once meetings were convened. This basic contradiction explains in part the OET boards confusion over its roles and responsibilities. The psychic stress that came from these "two unreconciled strivings" within the Oakland Ensemble Theatre board manifested itself in a paralysis in its relations with staff/artists.

Nowhere was the dilemma more evident than when it came to the board raising money. Perhaps out of a deeply seated sense of

self-hate, perhaps out of a victim's mindset, the OET board spent years deciding whether it was appropriate for them both to give money and to raise it. While this problem is universal in many misguided trustee situations of any race or culture, the peculiar spin on it for us was the prevalent thought that someone else will and should pay the bills. The OET board believed for years that under its oversight, staff was hired to raise all the money. If more money was needed, staff simply would be directed to work harder and write more grants. Volunteering one's time as a trustee was as good as giving money, or so the thinking went. To offer time and money was to them an unfair assessment.

Years of not-so-gentle coercion on staff's part won a partial victory. The board agreed in time that giving money annually was indeed appropriate. But it only required each member to give the lowest giving category which the theater offered, $35. Giving above that amount was to be a matter of conscience and ability to give. Board-sponsored fund raising activities, what little there were during my eight years, required such heavy participation of staff time that the events were virtually organized and administered by staff and non-board volunteers.

The contradiction I am herein raising is the acceptance of a posture of powerlessness on the part of trustees, those who volunteered to steer the health of the institution and accept a fiduciary responsibility. The subtext of this constricting self-imposed self-image bemoans how much more capable whites are than African-Americans at giving and raising money. The acceptance of the myth of white superiority in this area triggered in the minds of OET trustees a paralyzing welfare mentality. As poet Margaret Walker once put it: "We discovered we were black and poor and small and different and nobody wondered and nobody understood." Tensions flared when staff/artists openly questioned the boards lack of action in giving and raising money. We never succeeded in getting mutual agreement to a vision of shared fiscal responsibility because the mere mention of the

contradiction by staff was viewed as punishable subversive behavior.

Discussions about the relationship problems between staff/artists and the board of trustees never found a holistic forum. The "World of View" thinking board leadership required written documentation, memos, and strict adherence to procedural protocol. The structure of board meetings was regimented into committee reports where discussions were fragmented and compartmentalized. Whole-brain discourse, streams of consciousness, and impassioned communication, the very stuff of drama, were disallowed and viewed as immature and unwieldy behavior. Communication of grievances from individual board members to staff never occurred directly. Trustee concerns were communicated to the board president, the de facto World of View Commander-In-Chief, who in turn interpreted the content of those comments to me, often in letter form. The theater's Managing Director and Director of Development, both integral members of the staff, always attended board meetings but were not themselves board trustees. Their ability to speak freely at meetings was curtailed. Some trustees suggested they speak only when given permission to give a report, or in answer to questions posed to them. Still others felt they should retreat from the table to a remote corner of the room when they were no longer needed.

One might imagine how difficult staff found it to work effectively with those guided by a thought system so antithetical to the way the theater itself was being run and its art created. Staff would not and could not accept the board leadership's desire to dominate when it had not earned the right to such opinions by virtue of its lack of financial participation. Monthly meetings where basic reports were made comprised the bulk of their contact with the theater's operations and prohibited their knowledge of anything but a cursory awareness of the theater's daily affairs. Attempts to convince the board leadership to adopt a more World of Event posture fell on deaf ears and generated in them contempt for staff/artists and outrage at the implied challenge to their authority. No matter what was standard practice in the field,

trustees believed Oakland was different. Change was threatening. After seven years, attempts at reform dead-ended. Radical surgery became the answer, and all but two trusted and open-minded trustees found themselves compelled to retire.

A RETURN TO ROOTS

For African-Americans, I believe what's needed is a reclamation of a World of Event communal approach to leadership in the building and sustenance of its professional theaters. Operating a theater cannot be a perfect democracy, so leadership can shift according to the demands of the situation as long as mutual respect exists among the institutional partners. In the theater's heart must be a respect for the intelligence, experience, and resourcefulness of professional staff/artists who, by merely surviving, have evidenced brilliant business know-how. As well, respect for the contributions of trustees must exist. But an equation more co-equal than what World of View thinking allows should be the operating paradigm.

From both staff/artists and board trustees, the adoption of an empowering World of Event self-image is essential to a self-definition that embraces the power of community, the third institutional partner as the basis for achieving common objectives. It was a reliance upon the collective resourcefulness of community that enabled African-Americans to transcend the New World slave experience. It was a sense of self-determinism and mutual cooperation that enabled African-Americans to devise strategies to endure the weight of oppression and develop infrastructures and organs of self-expression that sustained and nurtured us as we synthesized our evolving American selves with our African selves. The notion of community involvement in and responsibility for institutions we hold near and dear—so well understood in the church—needs to be transferred to African-American arts institutions. This requires the full and active participation of all classes, circles, and segments of the black community.

The bourgeois conceit that a middle-class person is more qualified to lead than another should be eschewed in favor of mining expertise from any knowledgeable, competent resource willing to work. Effective board leadership must be identified, trained, and cultivated and is not automatically endowed with ones entrance into middle-class status. Measures of success determined by symphonic processes would set up the possibility of collective ownership of the institution where honest self-policing becomes a non-threatening necessity. Accountability becomes mutual. An individual's sense of self melds into a sense of the institution. The psychology of powerlessness, which generates a dependent posture, should likewise be replaced by a demonstrable faith in the power of many people contributing, each in their own way, to an idea they helped form that is greater than any one of them.

The political and sociological importance of theater in a community's life should be identified and understood as more than a social club for its board members and solely as an entertainment outlet for the public. African-American theaters are as much political statements, declarations of our right to be, affirmations of our distinctness, forums for collective learning, and opportunities for community economic development as they are centers of art and enjoyable social diversions. In the presence of such expanded communal institution values, assertions of individual ego that do not contribute to the collective vision will appear out of place. Class divisions would be less divisive in the realization that theaters as vehicles for social/political/economic change should embrace the full range of the economic strata that African-Americans occupy. Poor and working-class blacks by far comprise the majority of the nation's black population.

This is an important departure from the traditional European-derived notion of arts institutions as the playthings of a privileged and idle bourgeoisie. If African-American theaters can be seen as a reflection of a community's united strength, there will be room for

everybody because it will be a living force to which everybody can feel comfortable contributing.

The hierarchical power relationships inherent in World of View thought are particularly out of place for African-Americans because the black middle class does not command nor influence enough financial resources to assume the traditional posture of a trustee responsible for effecting sizable fiscal resources for the theater. This facet of the not-for-profit structure is a difficult fit for African-Americans. To ask staff/artists who actually run theaters to pretend to give up the ownership of their institutions to the oversight of trustees who neither understand about the art form nor contribute significant dollars to them nor divert substantial resources to them is a sham transaction with dangerous psychic repercussions.

Theater going is a growing habit among middle-class African-Americans, but as a regular habit it lies outside the experience of the majority of African-Americans. For a black community to build, develop, and nurture a professional theater of its own it must fully comprehend that to enjoy the privilege of having it, a collective responsibility is required in sustaining it. Lots of people giving small amounts and doing something, some small anything useful and helpful can produce miracles. To expect others outside of us to pay all or most of the bills is naive. Relying solely on a stretched and often splintered black middle class is not the answer either, because the assets of the black middle class as well as their ability to broker substantive power in the traditional sense have their limits. To expect them to posture as governors true to the traditional not-for-profit structure is dislocating. The participation of the total black community must be central.

When African-Americans ape "the man" by playing World of View power games in our involvement as volunteer board trustees with our arts institutions, we are courting a fragmentation of our sense of self which can have dire consequences. Head tripping and showing out are counterproductive and damaging particularly in

these hostile times of reactionary conservative retrenchment. We ain't totally free yet. Those rituals and ceremonies rooted in our culture which, when applied in other facets of our lives, bind us as a whole people and affirm both our collective self-worth and our ability to accomplish anything together must find their way into the work culture and governance of our theaters. New models of leadership based upon more open and tolerant World of Event-ness more consistent with our history in the New World must be essential before our arts institutions can enjoy a relative stability free from the psychic disorientation of measuring ourselves through the normative eyes of others.

THE COMMUNITY DIMENSION

Miriam Abrams

With our feminist goal of promoting women's musical achievements, the Women's Philharmonic is a political as well as an artistic organization. Feminist sensibilities strongly influence both the flavor of our concerts and our decisions concerning board and staff development.

Our audience comes to hear excellent music, and they are equally motivated to be a part of "history in the making." Most often, the audience will be on its feet, cheering a new work written for the Women's Philharmonic and/or buzzing excitedly during intermission about a newly discovered 300-year-old work by a woman composer. We provide free childcare during each performance, and the entire audience is invited to meet the conductor, orchestra members, and composers at a free reception after each concert. Performances and/or compositions by women of color are a regular part of our season, and a sizable proportion of our audience are lesbians.

One aspect of the Women's Philharmonic that I find most unique and exciting is the feeling of ownership of the orchestra by the audience. Both performers and audience members have the sense that this is a shared experience in the exploration and discovery of wonderful, neglected music. Almost every guest who performs with the Women's Philharmonic, who also performs with numerous other orchestras and ensembles, is enthused about the experience and delighted with the audiences response.

Sound like just a female version of your typical symphony orchestra? Not hardly. Likewise, our board shares more similarities with a community-based theater than it does with the San Francisco Symphony. We are somewhat of a "misfit" in the world of symphony orchestras—one of the most conservative worlds of all the arts institutions.

I recently attended a workshop on board development at an orchestra conference, and the panelists represented some of the most successful orchestras in the state. One of the panelists stated that the criteria for board membership are, basically, wealth, wisdom, and connections. This underlined for me the difference between the Women's Philharmonic criteria for board membership and that of other orchestras. First and foremost, due to how much we are a mission-driven organization, our board members must be wildly enthusiastic about our organization and its mission. This drives all our other requirements.

Our board members are asked to subscribe and attend all concerts, serve on a committee, make a donation to the organization, participate in fund raising efforts, and work an average of ten hours per month for the orchestra. We are committed also to diversity on our board in terms of age, race, and sexual preference.

The donation requirement from our board members began as a bit of a dilemma. Because of the diversity of our board, their capacity for giving ranges from $100 annual gifts pledged on a monthly basis to gifts of $5,000. We did not want traditional board standards to stand in the way of fulfilling our mission so we settled on wording that stressed the gift board members make to the Women's Philharmonic be among their largest gifts to any organization. This clarifies that each member makes a major financial contribution according to her own means.

The Women's Philharmonic enjoys an excellent relationship between board and staff. Together, we more closely resemble two aspects of one team rather than members of a hierarchical structure.

Despite this, the structure and conventional wisdom of the function of boards of directors of non-profit organizations in general is bothersome to me in the first place.

Traditionally, boards of directors have two major functions: fund raising, including their own individual giving, and making policy. For the life of me, I can't seem to reconcile these two functions as the responsibility of the same group of people. While having a role in policy making helps fuel enthusiasm and responsibility for fund raising, one can't construe that some of the best fund raisers would necessarily be the best policy makers—and vice versa. These are two very distinct functions that are being merged together in one body. This view also determines that institutions with large budgets, that are heavily dependent on individual support, will by necessity be governed by wealthy individuals or by those who have access to wealth. In other words, they become elitist institutions by nature—no matter how many community outreach programs one develops.

It's quite common for orchestras to have 90-member boards. Most of these members are invited to join the board only because of the size of their gift. While some may argue that most of the work is done by a smaller executive committee, the structure of the organization still ensures that it is run by wealthy individuals, and people with lesser incomes (or no incomes at all) are shut out of the governing roles of these institutions.

Aren't all non-profit organizations, and certainly arts organizations, supposed to serve the community? Shouldn't the board of directors reflect that community in the manner that it is defined? There has recently been some effort on the part of major arts institutions, many of whom are bowing to public pressure, to include more people of color on their boards of directors. But if arts organizations are to serve their entire communities, as they propose to do, shouldn't they be governed by people from throughout their community, including those of diverse income levels?

In fact, how people are elected to serve on many boards of directors makes them, almost de facto, a self-perpetuating club. Most often, the members of boards nominate and elect their new members. How can we ensure that this is not a closed circle?

While it's easiest to see these principles in action with larger arts institutions, I think most arts organizations slip into this condition, including the Women's Philharmonic. By the very nature of how much money we need to raise each year from individuals, foundations, and corporations, we must try harder and harder to bring people onto the board who can give and raise more money.

The Women's Philharmonic has not solved this problem, but we do have a commitment of bringing onto the board the best qualified people, not the ones with the most wealth or connections to wealth. We have resisted the temptation of inviting a person onto the board who is capable of fund raising or giving a large donation but who does not enthusiastically support the organization's political and artistic viewpoint. We continue to try to cultivate these people as donors, with mixed success, and try to find ways for them to become a part of the organization without endowing them with decision-making power. We have also launched a national direct-mail campaign to broaden our base of support.

It is unclear what the "ultimate" answer is, but it is clear that it will be found only by making this a priority topic for in-depth discussions of arts administrators, funders, and board members.

CONCLUSION

As we have described, the environment we are working in today has steadily grown more complex and confusing. Contradictions dominate our work and lives. In recent years, world and human events are remarkable for both their great change and great stasis. From the end of the cold war era with its celebration and affirmation of one long struggle for human rights to the rise of religious fanaticism and its opposition to free expression and human rights, we find ourselves caught between powerful forces. Newton's law, every action creates an equal and opposite reaction, takes on new meaning. For each compelling action or movement toward change, there is a corresponding inaction or movement to prevent change. This is the contemporary reality within which we must function.

Most importantly, we must realize that these contrasting forces don't just exist "out there." The very same forces of opposing action and inaction exist within each and every arts organization. It is not possible to influence other individuals, community, or world views without first dealing with the contradictions within our own organizations.

Over the years, the ideals and theories of arts boards have functioned like a body of mythology—they have conveyed worthy ideals, but have always been better informing rather than instructing. Perhaps in the past, it didn't matter how effectively a board functioned because resources were adequate and the political and

community environment was sufficiently positive. But dogged adherence to old formulae, theories, and myths has to be discerned and rejected before new approaches are implemented and allowed to flourish.

As we all now know, there has probably never been a time in which arts professionals could simply turn their lives, organizations, and trust over to a group of community lay people and assume that everyone would work with the same spirit toward the same worthy ends. Yet, even so, with life's increasing difficulties, the solution boils down to a pretty simple premise.

That is, the board can no longer be an excuse or reason why an organization is not fulfilling its mission or serving its community. For positive and productive change to occur, arts professionals—the artists and arts managers who need and thrive within arts organizations—must vigorously grab the responsibility to lead and direct their organizations and their communities. As stated earlier, bankers, lawyers, accountants, and other community leaders may believe strongly in having artists and arts organizations in their community, but they don't need them. We affirm that the arts require and appreciate support from these individuals and the community, but this relationship need not be asymmetrical or unhealthy.

Arts professionals must strive to be proactive and use the approaches, methods, and tools tailored to their needs and reject the "well-intended," but ineffective "myths" that have been handed down. The arts community must not allow itself to be held hostage by methodologies which depend on the whim and will of others inside and outside the organization who would control and direct yet make no real commitment.

We must be willing to make tough decisions and fight with enthusiasm for our much deserved resources. Unless more arts professionals claim responsibility and authority for their own organizations, we cannot expect board members or anyone else to do more for us than we are prepared to do for ourselves.

ABOUT THE AUTHORS

NELLO MCDANIEL is the director of ARTS Action Research. Prior to founding ARTS Action Research with George Thorn, he served as Executive Director of FEDAPT, a not-for-profit arts consulting company based in New York. At FEDAPT beginning in 1981, he directed numerous national conferences including *The Challenge of Change* and eight Performing Arts Management Workshops at the Eugene O'Neill Theatre Center. Nello has published essays and articles in *Vantage Point, Dance/USA Update, Journal of Arts Management and Law*, FEDAPT's *Challenge of Change, WorkPapers 1: Rethinking and Restructuring the Arts Organization, WorkPapers 2: Arts Boards*, and ARTS Action Issues' *The Quiet Crisis in the Arts*, and *Toward a New Arts Order*. From 1978 to 1981, he managed the Presentation and Touring Programs for the National Endowment for the Arts Dance Program. Before that, Nello served as Chief Operating Officer and Performing Arts Services Director for the Western States Arts Foundation, a ten-state regional arts consortium now based in Santa Fe, New Mexico.

GEORGE THORN divides his time between co-directing ARTS Action Research and directing the graduate program in Arts Administration and co-directing the Arts Management Institute at Virginia Tech in Blacksburg, Virginia. From 1987 until 1991 he was the associate director of FEDAPT. He is co-author with Nello McDaniel of FEDAPT's *The Challenge of Change, WorkPapers 1: Rethinking and Restructuring the Arts Organization, WorkPapers 2: Arts Boards*, and ARTS Action Issues' *The Quiet Crisis in the Arts*, and *Toward a New Arts Order*. Prior to these activities, he was the fiscal and administrative officer of the Eugene O'Neill Theatre Center. George spent sixteen years in New York where he was a stage manager for eight years; he also had a private general management firm through which he managed Broadway, Off-Broadway and touring companies.

BENNY SATO AMBUSH is a veteran theater professional with national and international experience as a director, educator, producer, and arts administrator. Before joining American Conservatory Theatre he was the Artistic/Producing Director of the Oakland Ensemble Theatre for eight years. Prior to OET, he served as a National Endowment for the Arts, Arts Management Fellow in its Special Projects Program, as an Assistant Director-in-Residence at Washington D.C.'s Arena Stage, as an NEA Directing Fellow at the Pittsburgh Public Theatre, and as a United States Information Agency sponsored lecturer at Kenyatta University, Nairobi, Kenya. He is a member of the Multi-Cultural Advisory Council for the California Arts Council, and has been active in advocacy for cultural equity, non-traditional casting, and pluralism in American art. Benny received his BA in theater arts and dramatic literature from Brown University, and his MFA in stage directing from the University of California, San Diego.

MIRIAM ABRAMS is an arts consultant, serving such diverse clients as the Dayton Hudson Foundation, Tides Foundation, Pomo Afro Homos, Classical Action: Performing Arts Against AIDS, Redwood Cultural Work, and others. She has long been a champion of women in the arts and community arts in the San Francisco Bay Area. Miriam is co-founder and former Executive Director of the acclaimed Women's Philharmonic in San Francisco. Under her leadership, the Women's Philharmonic became an national organization serving orchestras and women composers around the world. During her tenure, the Women's Philharmonic received 10 awards form ASCAP and the American Symphony Orchestra League for adventuresome programming. Miriam is a member of the Performing Arts Advisory Committee for Center for the Arts at Yerba Buena Gardens, served on the Cultural Arts Task Force of the City of San Francisco, and is a member of the board of directors of BRAVA!, a multi-cultural organization promoting women in the arts.

ABOUT ARTS ACTION RESEARCH

ARTS Action Research is an arts consulting and research group founded and co-directed by Nello McDaniel and George Thorn. "Action Research" is a term borrowed from the social sciences. Rather than studying what has been, action research explores ways to effectively intervene to influence and ignite evolution and change. ARTS Action Research is committed to discovering, understanding, and creating the systems, methodology, vocabulary, dynamics, and culture of change within the arts community.

ARTS Action Research is committed to helping arts professionals and arts organizations bring about positive change in their work, lives, and communities.

ARTS Action Research:

- Consults with arts organizations, individually and in consortia, on planning, reconceptualizing, and restructuring.

- Organizes and facilitates special workshops and conferences to examine needs, problems, and issues effecting the arts community.

- Initiates special research or "laboratory" projects to develop, examine, and test new concepts and approaches to structuring and operating arts organizations.

- Documents and disseminates the findings of this work through special reports and other publications. **ARTS Action Issues** is the official publication and distribution arm of **ARTS Action Research**.

OTHER PUBLICATIONS
FROM ARTS ACTION ISSUES

- **Toward a New Arts Order/Process, Power, Change**

 The arts continue to be caught in a crossfire of circumstance and conditions that are both unprecedented and unrelenting. Arts professionals can either choose to live with the chaos, or create a new order for their organizations and the arts community. Nello McDaniel and George Thorn make a strong case for the latter, exploring new concepts, applications, and approaches that can help arts professionals create healthier, more productive organizations.

- **The Quiet Crisis in the Arts**

 This special report by Nello McDaniel and George Thorn is a hard-hitting, no-nonsense analysis of circumstances and conditions underlying the current crisis in the arts. The Quiet Crisis also provides the most concise, practical and humane approaches to dealing with the organizational crisis and dysfunction, available to arts professionals.

- **Rethinking and Restructuring the Arts Organization**

 This book by Nello McDaniel and George Thorn and other contributing writers, examines the viability of the traditional not-for-profit arts model while exploring new ideas and organizational approaches. It also features first hand accounts of how eight professional arts leaders approached restructuring their organizations in response to today's challenges.

Publications may be purchased through **ARTS Action Issues**. To receive an order form call 718-797-3661 or write **ARTS Action Issues**, P. O. Box 401082, Brooklyn, NY 11240